An artist's workbook

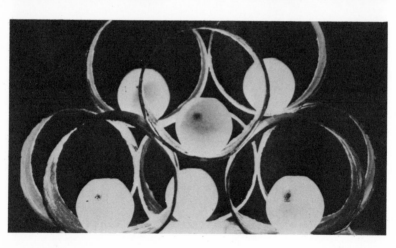

An Artist's Workbook

LINE SHAPE VOLUME LIGHT

Natalie d'Arbeloff

Photographs by Ted Sebley

Studio Vista : London

Van Nostrand Reinhold Company : New York

For Sacha, Blanche and Christopher

© Natalie d'Arbeloff 1969
Published in Great Britain by Studio Vista Ltd
Blue Star House, Highgate Hill, London N19
and in the United States of America by Van Nostrand Reinhold Company,
450 West 33 Street, New York, N.Y. 10001

Set in Univers 689
Printed in Great Britain by Butler and Tanner Limited
Bound in Great Britain by Webb, Son and Co

SBN 289 79615 6

Contents

Acknowledgements 6
Foreword 7
Introduction 9

1 Inventory 12
 Line 14
 Shape 22
 Volume 28
 Light 34

2 Explorations 40
 Time 42
 Space 51
 Structure 61
 Chance 67

3 Concentration 83

4 Synthesis 95
 Harold Cohen Michel Seuphor L. Alcopley
 Derrick Greaves Francis Bacon Vasarely
 Euan Uglow Jack Smith Mary Martin
 Ted Sebley Roy Lichtenstein Frank J. Malina

Appendices 120
Materials 125
Bibliography 128

Acknowledgements

I would like to thank the following artists who have generously allowed me to include examples of their work and also, in many instances, to quote from their own comments about it: Derrick Greaves, Michel Seuphor, Harold Cohen, L. Alcopley, Euan Uglow, Jack Smith, Mary Martin, Jerry Duff, Jerry Pethick, Desmond Paul Henry, and Frank J. Malina: I am particularly indebted to Dr. Malina, Founder-Editor of the journal *Leonardo* which has been very useful to me. My thanks are due also to Pergamon Press, Oxford (publishers of *Leonardo*); to *Studio International,* London; to *Artforum,* New York; to *London Magazine;* and to Joost Baljeu editor of *Structure,* Amsterdam, for giving their kind permission to reprint extracts from copyrighted material. I wish to thank David Sylvester for permission to quote parts of his interview with Francis Bacon, and Francis Hoyland for his comments on Euan Uglow's work. Also the galleries Denise René, Paris; Leo Castelli, New York; Marlborough Fine Art Ltd, London, Axiom, London, and Kasmin Ltd, London, for their helpfulness. My thanks to Kenneth C. Knowlton and Leon D. Harmon of the Bell Telephone Laboratories, New Jersey, for allowing me to reproduce their computer-nude.

I want to express my sincere gratitude to my brother for his help and encouragement; also to Ted Sebley for the many excellent photographs and for allowing me to include an example of his painting. Last but by no means least, my thanks are due to my students at the Camden Arts Centre, London — those whose work is illustrated, and all the others — whose enthusiastic spirit of enquiry was directly responsible for my writing this book.

Foreword

The art of the past furnishes countless instances of the extent to which the visual artist has been committed to the study of nature as the mainspring of his pictorial invention. The value of keeping sketchbooks and notebooks was never questioned; it was accepted as a necessary part not merely of an artist's training but as a continuing means of his retaining and replenishing his vocabulary of forms and notions of structure. It provided him with a storehouse of germinal ideas for later development; Watteau, Constable, Samuel Palmer come to mind as strongly contrasted examples of artists who made continuous use of sketchbooks; and, looking at these, one is acutely aware of their differing creative personalities and the way they express the nature of their working needs in their notes and sketches. Cézanne's statement 'Art is a harmony parallel to Nature' has often been used to indicate the relationship of the less directly representational art of the twentieth century to nature, now greatly extended by science and technology and revealed by photography of ever-increasing range and effectiveness. Paul Klee's well-known notebooks are largely concerned with demonstrating the formal elements of art as something analagous to nature, as when he writes 'Just as a child while playing imitates us, so we while playing imitate those forces which have created and continue to create the world'.

There are very good reasons for believing that our response to abstract art, in so far as it has significance for us, is conditioned by association with the external world of tangible forms, sensuous experience of space, psycho-physical reaction to the laws of the real world; only an individual who is, or who has learnt to be, deeply concerned about physical substance and physical space of the external world can hope to produce meaningful non-figurative work. But the education of this response calls for an extension in the manner of using notebooks, and many a young student is unclear not only about the value of this aspect of his studies but also, even when convinced, about the nature of the graphic note-taking activity itself.

Natalie d'Arbeloff has given in this book an admirable example of such a notebook, or, as she more properly describes it, a workbook. And let it clearly be understood that she offers it as *her* version of this activity in the hope that it will encourage each of her readers to think more seriously and more meaningfully about the activity of graphic notation. Emphatically, it is not offered as a stereotype, but as a provocation to more searching personal involvement in investigatory studies. For the author, it has seemed very necessary to consider a workbook not as a means of collecting, magpie fashion, interesting and arresting scraps of visual information, but as a directed study arranged under the broad sub-divisions relating to the main aspects of formal language — line, shape, volume, light — and to provide a

translation of these visual experiences and stimuli into the materials with which she is concerned as an artist.

The distinction between 'looking' and 'seeing' cannot too frequently be emphasized; this workbook is a vivid demonstration of the artist's vision and is an education in perception no less important for the layman interested in the visual arts than for the young art student. It is as a means of deepening not only our response to the external world and to the range and creative flexibility of the materials we use, but also of cultivating the power of invention, that a workbook has its full meaning and value. Gyorgy Kepes reminds us of this when he writes 'The difference between a mere expression, however intense and revealing, and an artistic image of that expression, lies in the range and structure of its form. This structure is specific . . . An artistic image, therefore, is more than a pleasant tickle of the senses and more than a graph of emotions. It is meaning in depth, and, at each level, there is a corresponding level of human response to the world.'

Natalie d'Arbeloff clearly defines the nature of a workbook as a personal inventory of formal ideas, and she is well aware that it has its ultimate justification only in the development of works specifically related to the individual creative talent and temperament. It is, at one and the same time, a means of study and a spur to creative thinking.

May 1969 Maurice de Sausmarez

Introduction

Normally, 'to see' is to take in many kinds of information without necessarily selecting any one specific message. We don't usually, for example, go about looking at light without associating it with the objects it is illuminating: yet light is a different *kind* of visual experience than, say, shape.

For anyone concerned with expression by visual means such distinctions are important, and 'to see' becomes 'to choose'. The fact that we are able to see – or experience – a thing in more than one way is taken very much for granted. What I am suggesting is that this ability be consciously exercised, developed and used to explore not only what our eyes tell us but also that which we perceive intuitively.

We are used to those changes of mind, or mood, which take place so often in the course of our everyday lives: we say the 'atmosphere' of a place is not the same tonight as it was last night; a familiar face suddenly seems strange; an object we attached immense importance to a while ago becomes insignificant; something we have always taken for granted assumes the aspect of a revelation.

Translated into terms of creative activity, 'changes of mind' becomes a deliberate putting of one's self into a state of open enquiry where it is possible to move freely from one kind of perception to another without losing one's balance or being superficial. To illustrate, here is a very simple example:
Examine your hand and ask yourself to *look for line:* you immediately begin selecting those aspects of the total impression which your mind classifies as 'linear' – the patterns of lines on the palm, wrinkles at the joints, and so on. If you now change the order to: *look for shape,* you scan the contours of the whole hand, notice the shape of each finger, the spaces between fingers, etc. Change again to: *look for volume,* and you become aware of the weight of the hand, its solid bone structure, its ability to act as a container. Now change to: *look for light,* and you find that in order to focus on this particular aspect, it becomes necessary to somehow break up or abstract your view of the hand, and perhaps you are left only with a fleeting impression of colour, texture, moving shadows.

I use the words line, shape, volume, light as convenient abbreviations for a wide range of visual experiences which everyone interprets somewhat differently.

Putting what is essentially a continuous whole into four separate categories and examining each in turn has a functional purpose: it is a possible method of isolating what one can creatively use out of the chaos of information supplied by innumerable sensory stimuli, by techniques, trends, theories, and by the unrealized potentialities within one's self.

I am addressing myself specifically to the individual – whether art student, teacher, professional or amateur – who is

concerned with transforming what he perceives into images or artifacts. As a painter, I have always hoped I would come across a practical manual which would sum up the questions in my own mind concerning visual appearances and also those levels of perception seen only with the mind's eye. Through teaching I realized that others, too, hoped for such a guide-book but that no matter how helpful someone else's experience and ideas might be, the most useful manual of all would be one devised by one's self according to one's own needs. I have therefore attempted to make a working model of such a manual. This is only a beginning: I hope it will serve as a spur to the reader to undertake a similar experiment.

Fig 1 a, b, c, d

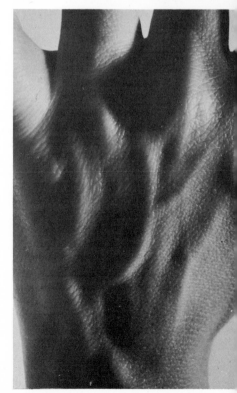

1 Inventory

Line, shape, volume, light: as long as these remain words, they are only abstract generalities. The aim of preparing an inventory is to make them tangible, useful to yourself, considering them as though for the first time, regardless of your past experience.

It is important that such an inventory should be devised for *your own* use: the framework I have outlined is merely an example and comes to life only when personally interpreted. It is not necessary to compile an elaborate encyclopedia. A miniature catalogue, in which every item has been carefully chosen for its value to the individual, becomes a vital working tool. In the sample inventory on the following pages, I have linked together selected words, photographs of natural forms, questions – and the technical ideas which arose out of these.

The search for words is a matter of visualization: 'slot' and 'slit', for example, call up different mental images. I see 'slot' as a straight opening in a hard surface, whereas 'slit' is more like a hairline cut in paper or cloth. These images, in turn, suggest techniques which suggest variations, and so on. The only words necessary to your inventory are those which provoke an immediate response in yourself, starting up a chain-reaction of ideas.

Photographs provide an invaluable aid to direct observation, making it possible to lift out from nature only that detail which seems significant. It is easy to become absorbed in this aspect of the research as an end in itself – similarities between nature and art are, with the help of photography, continually being revealed. Hypnotic as such comparisons might be, it is essential if the inventory is to function effectively, to subject yourself to some sort of discipline. As to how you choose, for example, from a hundred objects which would illustrate *shape,* the question to ask is not: 'Does this illustrate shape?' but: 'Is there something in this which answers a question for me, and if so, *what?*' A great deal of material which although attractive has no particular value to yourself can thus be discarded, making it possible to extract important information from those few examples which are retained.

The form of the inventory is a matter of personal choice. Every technical idea ought to be followed through all its variations, with a sample for each stage, to be developed later on. For convenience, these samples might be kept to a uniform size. They are essentially only notes for future reference but could, of course, stand up in their own right.

Whatever format you decide on, it should allow for continuation and expansion and be kept within reach and well in view, so as to become not dead matter stored away among finished projects, but a constant reminder of possibilities you *actually* have in hand.

At a time when technology and art education at all levels

offer so much in the way of equipment, methods, and ideas for self-expression (including suggestions for applying the results to specific goals, from do-it-yourself home decorating to industrial design) I feel it important for the individual to return, at least once in a while, to the situation of primitive man rubbing sticks together: not to ignore progress but to re-discover through firsthand experience. Basing your research on clarifying the four headings line, shape, volume, light, is not, of course, a hard and fast rule. It does, however, work very effectively in allowing for both variety and specialization.

Each question in the inventory suggests a theme, a starting point for intensive research and experiment, to be carried out on one's own or as a group project in a school. Preparing an effective inventory, as I see it, requires a persistent inquisitiveness about what one sees and an ability to invent spontaneous methods of recording one's responses.

I cannot over-emphasize the point that techniques ought to be the result of an intensely personal question-answer process rather than dabbled in for their own sake. The examples in the following pages are *only* examples, not substitutes for that process.

Line

1 What kind of line?

Look around: no lines in nature – but what *seems* to be a line? Narrow gaps between solids, edges of solids, minute particles close together, etc. How are these made, what is their character?

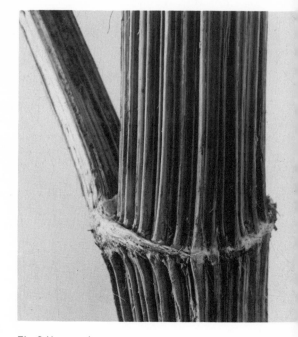

Fig 2 Hogweed stem

INTERVAL

GROOVE

INCISION

FISSURE

TEAR

SLIT

SLOT

SCRATCH

WRINKLE

RIDGE

FILAMENT

WISP

Fig 3 Cornsilk

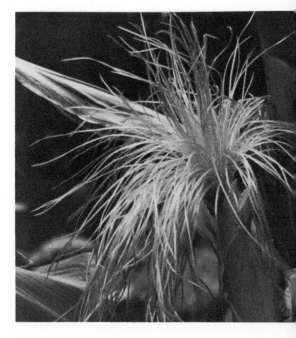

Techniques

Fig. 4 Wood units (these are from a toy construction set), spaced at irregular intervals, mounted on a hard surface

Fig. 5 Crumpled paper, ink allowed to run into the wrinkles. Pale wash of ink brushed over the surface

Fig. 6 Lines incised in a block of wood, following the patterns of the grain. Lines then filled with black oil paint and the surface of block wiped clean (as in wiping an etched plate). White paint then applied to the surface with a roller

Fig. 7 Primed canvas, folded, slit with razor blade, and glued to a wooden base

Fig 4

Fig 5

Fig 6

Fig 7

Try making lines with a great variety of tools on all kinds of surfaces. Besides the usual drawing instruments, improvise with ready-made materials: wire, string, synthetic fibres, dowelling, metal rods, wooden slats, reeds, etc. Find the character of line which suits you best.

Line

2 What texture?

What an edge feels like to
the touch, how it looks
when magnified.

Fig 8 Dry creeper stems

FIBROUS

HAIRY

WOOLLY

SILKY

WIRY

JAGGED

THORNY

GRANULAR

STIPPLED

SPOTTED

SERRATED

SCRAPED

Fig 9 Fossil in rock

Techniques

Fig. 10 Lines drawn with glue, then sprinkled with sand

Fig. 11 Drawn with water-filled brush, then lightly touched with Indian ink which spreads in the water channels, leaving a sediment

Fig. 12 A line drawn with Indian ink is covered with Sellotape (Scotch tape) while still wet. The ink spreads and stops in a pattern. The Sellotape is lifted off, some of the ink pattern still clinging to it — enough to make one or two 'prints'

Fig. 13 Pencil lines on rough canvas-backed paper

Fig 10

Fig 11

Fig 12
Fig 13

Try altering the character of a line while it is being made, or after it has been made, by the use of textures. Note how the texture of a surface can suggest or create certain kinds of line. Possibilities include lines which are burnt, engraved, etched, carved, etc.

Line

3 What patterns?

What happens when edges
are close together, or
touch at regular or
irregular intervals, or run
alongside each other?

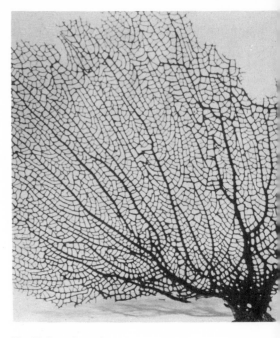

Fig 14 Branch coral

FILIGREE

WEB

Fig 15 Sweet-pea tendrils

LATTICE

MESH

NET

KNOT

TANGLE

CHAIN

BRAID

STRIPE

CROSS

ARABESQUE

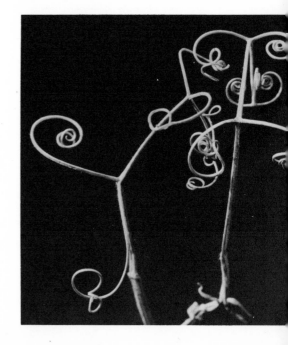

Techniques

Fig. 16 Geometric construction with string. First built inside a wooden frame, the frame then removed and the string stiffened with plastic spray fixative

Fig. 17 Stripes drawn on paper in various colours; the paper then cut up and the stripes, re-arranged in new patterns, pasted on to another sheet

Fig 18 Narrow adhesive tape, red and black, applied to paper by means of a 'tape-pen' (special tape dispenser, used for drafting, and so on)

Fig. 19 Dry-transfer printed shading sheets (e.g. Letratone, Zip-A-Tone) laid over one another at various angles, producing optical patterns

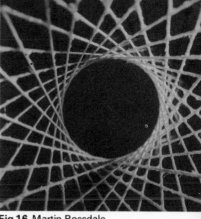

Fig 16 Martin Rossdale

Fig 17

Fig 18

Fig 19

Experiment with random ways of producing linear patterns, e.g.: a handful of matchsticks, toothpicks or bits of wire tossed on to a hard surface and glued into position where they fall. Prints can be made from such arrangements by inking up the surface of the lines with a roller and oil or water-based printing inks.

Line

4 What movement?

Letting the eye travel all along the length of any edge it can see, moving across to another edge, trying to *feel* the sort of course it is taking, the direction implied.

Fig 20 Cut cabbage

ZIGZAG

SPIRAL

UNDULATING

CONVOLUTED

VIBRATING

EXPLODING

STRETCHING

DROOPING

FLAPPING

FLOWING

TRICKLE

SPLASH

Fig 21 Hogweed

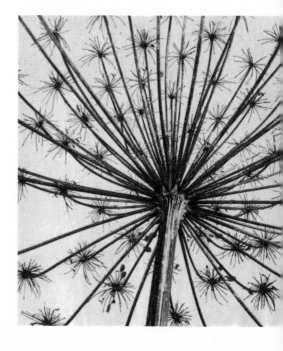

Techniques

Fig. 22 A piece of string dropped at random on a hard surface, a sheet of paper laid over the top and a rubbing made, using black Conté crayon. The string is shifted slightly several times and rubbed again

Fig. 23 Cut pieces of string, allowed to move under the paper while it is being rubbed

Fig. 24 A few small bits of wire, rubbed while they shift around under the paper

Fig 25 One piece of wire, moved along gradually under the paper while rubbing

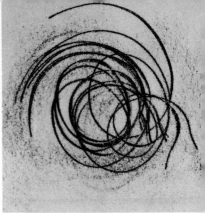

Fig 22

Fig 23

Fig 24
Fig 25

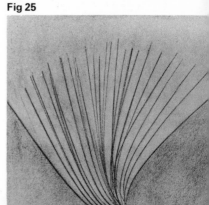

Action can be suggested by line with the simplest of means: a brush and ink, used with economy and spontaneity. Invent linear symbols for actions like running, jumping, etc. Also for natural forces – e.g. wind, fire, water, lightning.

Shape

1 What kind of shape?

Note the silhouette that a
shape makes in space, its
contours, the angle it is
facing.

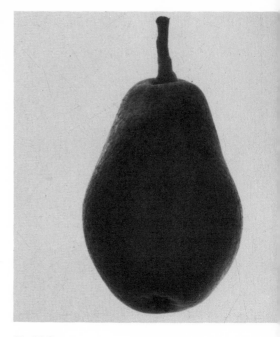

Fig 26 Pear

SYMMETRICAL

ELLIPTICAL

Fig 27 Nasturtium leaf

ANGULAR

ELONGATED

SQUAT

CONTORTED

DISTORTED

AMORPHOUS

BLURRED

FLUID

SCALLOPED

PERFORATED

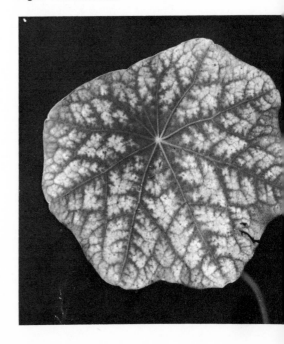

Techniques

Fig 28 Photogram: made in this case by holding a cardboard template at an angle over a sheet of photographic paper, exposing for a few seconds under the enlarger, then fixing and washing as for an ordinary photographic print. (A similar procedure can be carried out without an enlarger, exposing under any bright light in a dark room)

Fig. 29 A water-drawn shape, touched with Indian ink in places

Fig. 30 The old familiar folded ink blots system. Still good for discovering the most astonishing symmetrical shapes

Fig. 31 Paper folded in three different places, shapes cut out along the folds; the paper then opened out and mounted over another sheet, leaving a wedge of space between the two. Sections painted black

Try making shapes (drawn, cut, sawn, etc.) out of various materials: plastics, hardboard (Masonite), balsa wood, cloth. Experiment with ready-made or pre-cut units such as cork, Polystyrene, or ceramic floor tiles; jigsaw puzzle pieces, playing cards, etc.

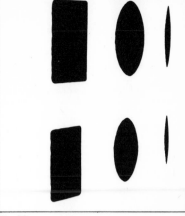

Fig 28

Fig 29

Fig 30

Fig 31

Shape

2 What relationship to other shapes?

The implied action which shapes exert upon each other, their relative position, size, tone, colour.

Fig 32 Sunflower bud

OVERLAP

INTERLOCK

SURROUND

ALTERNATE

ADVANCE

RECEDE

CONVERGE

PILE UP

CLUSTER

STRADDLE

DIVIDE

RAMIFY

Fig 33 Cut cauliflower

Techniques

Fig. 34 Rubbing, taken of overlapping sheets of cut cardboard

Fig. 35 String-rubbing again: this time, shapes are filled in with black and white gouache

Fig. 36 Sheets of coloured cardboard, folded and mounted on a base in various relationships to each other

Fig. 37 Gouache improvisation on the theme: black and white checkerboard, red squares, blue and yellow circles

Fig 34

Fig 35

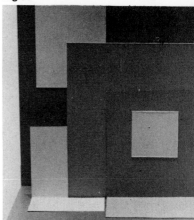

Fig 36
Fig 37

Try positive/negative shape relationships, using cut-outs in black and white paper. Letter or number stencil-cards can be used in many ways to make shape-patterns. Experiments with scale are relevant here, and making shapes seem to move forward or back by their dimensions, tone, or colour.

Shape

3 What surface?

How the texture of a shape
affects or creates its
contours, its 'profile'.

Fig 38 Aster

STUDDED

CORRUGATED

Fig 39 Beetle

PITTED

EMBOSSED

INLAID

MATTED

VELVETY

SPONGY

STAINED

LUSTROUS

SPRINGY

PADDED

Techniques

Fig. 40 White acrylic paint, textured by pressing round, plastic construction-set pieces into it; an ink wash brushed over the surface

Fig. 41 Wood stain rubbed into a board; white paint put on with a palette knife around the edges of the stain

Fig. 42 Glue relief; oil paint rubbed into it then wiped lightly off the surface

Fig. 43 Print made from a glue stencil: a pattern is drawn with glue (e.g. Casco) on to a piece of glass or plastic. When dry the glue shape is lifted off, coloured, placed on top of another coloured stencil, and the lot printed, either by rubbing or through a press

Fig 40

Fig 41

Fig 42
Fig 43

Some ready-made textures could be useful: embossed wallpapers, fabrics, etc. Try various kinds of coarse-grained canvas and paper; also smooth, polished surfaces such as glass, metal, formica — as a base for painting or drawing.

Volume

1 What dimensions?

Observe the kind of
volumes which surround
you (room, house); those
you can hold; those at a
distance. What is their
position in relation to you?

Fig 44 Stone

CAVERNOUS

SHALLOW

MONUMENTAL

MICROSCOPIC

NARROW

STEEP

CONCAVE

CONVEX

OVERHANGING

JUTTING

TOWERING

TILTED

Fig 45 Shell

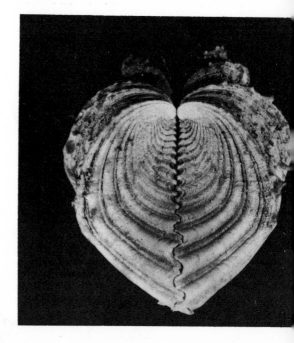

Techniques

Fig. 46 Cylinders cut from dry-transfer shading film (Letratone, Zip-A-Tone), applied to paper

Fig. 47 Black scraperboard or scratchboard (used for commercial illustration, etc), lines scratched through to the white ground with a sharp point

Fig. 48 Pen and ink. From the idea 'flying rocks' – one of many possible themes to help visualize size relationships

Fig. 49 Measured drawing, inventing a space which is ambiguous

Fig 46

Fig 47

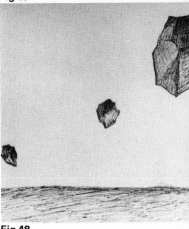

Fig 48
Fig 49

Do studies of simple geometric forms (boxes, cardboard cylinders) in monochrome. Look at the objects from various angles; sometimes they might fill the whole surface of the paper or canvas, sometimes appear only as minute solids in the distance. Try focusing on one aspect of volume, say, 'hollowness', and do a series of drawings or constructions on that theme.

Volume

2 What function?

What does a volume act as,
in relation to you, to the
surroundings, to other
volumes?

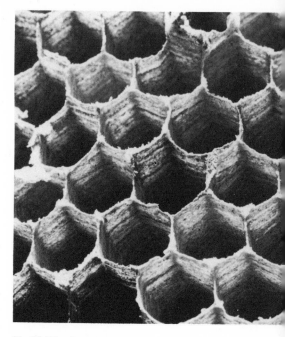

Fig 50 Wasp's nest

BOX

TUBE

TUNNEL

NICHE

COLUMN

DOME

VESSEL

BAG

WALL

SHELF

COMPARTMENT

BASE

Fig 51 Bone

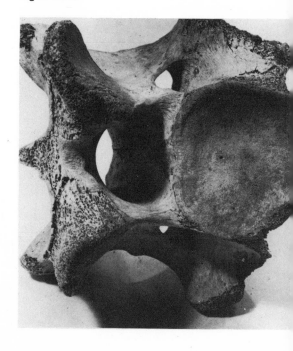

Techniques

Fig. 52 Construction, made with wooden blocks, painted

Fig. 53 Construction, with cardboard tubes and wooden balls

Fig. 54 Column, made of thin cardboard, folded and cut along the folds. Maquette for a larger work

Fig. 55 Found object (world globe) modified and adapted to a wooden base

Fig 52

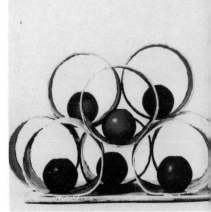

Fig 53

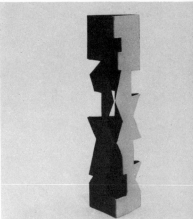

Fig 54
Fig 55

Other possibilities include modifications or assemblages of: boxes (wood, metal, cardboard), tin cans, cubes and spheres, various types of display equipment, toys, and so on.

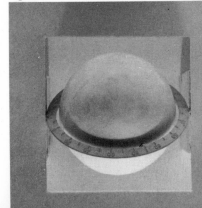

Volume

3 What possibility of motion?

How does a given solid behave under the action of natural forces, or subjected to artificially induced movement?

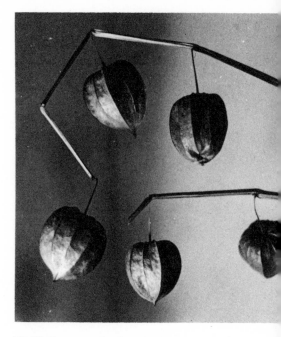

Fig 56 Cape gooseberries

FLUTTER

BOUNCE

BEND

ROLL

FLY

FLOAT

SPIN

SWING

TWIST

SPRING

VIBRATE

SLIDE

Fig 57 Poppy seeds

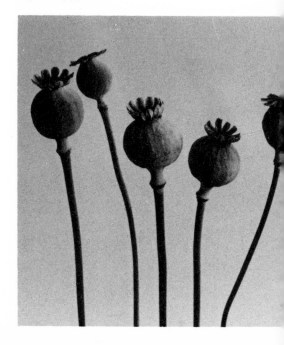

Techniques

Fig. 58 Mobile, made of wire and paper

Fig. 59 Construction: inside a box-like frame, perforated wooden blocks, painted on each of their faces, are threaded on to a wooden dowel-rod. When they are spun on the rod, the painted designs arrange themselves into different combinations

Fig. 60 A traditional Indian toy: it is in two separate sections; the top part merely rests on the pole and, when it is spun, keeps its balance on it. One of many found objects and toys which use simple principles of motion, and could serve as the basis for mobile constructions

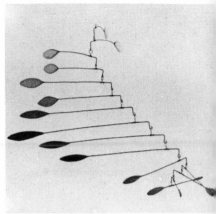

Fig 58

Fig 59

Try experiments with pendulum motion; with seesaw motion; with levers, pulleys, springs; with simple turn-tables such as a pottery wheel, or mechanically operated ones.

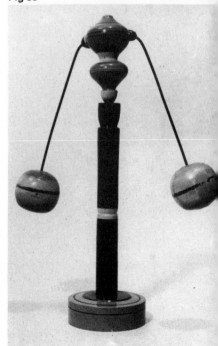

Fig 60

33

Light

1 What intensity?

Compare different kinds of
light, the prevalent colour
and *mood* produced by
various degrees of
illumination.

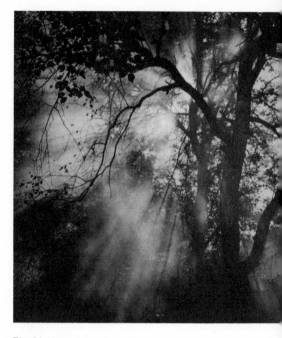

Fig 61 Light through smoke

MURKY

HAZY

Fig 62 Rose

SMOKY

MILKY

FROSTED

DIAPHANOUS

TRANSLUCENT

CRYSTALLINE

INCANDESCENT

DAZZLING

GLARING

SEARING

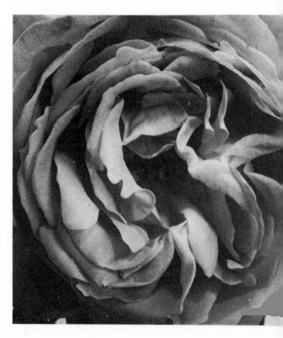

34

Techniques

Fig 63 Transparent sheets placed behind the openings in a template, lighted from behind. Tonal intensities varied by overlaying sheets of different density or texture. A similar exercise could be carried out in colour, e.g.: all possible intensities of red, as transparent colour, and as opaque colour

Fig. 64 Watercolour on thin Japanese paper, using a spectrum progression of colours: from intense red-violet in the centre towards orange, yellow, yellow-green, turquoise, blue, blue-violet

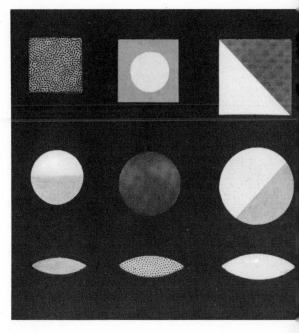

Fig 63

Fig 64

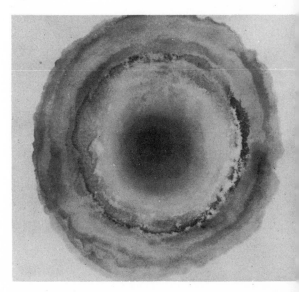

Try painting any object, seen through a variety of 'filters' (e.g. muslin or any other semi-transparent material; coloured cellophane; plastic; cloudy glass). A special box might be constructed for this purpose: the object put inside the box under various light conditions, and looked at through a frame over which the different filters would be placed.

Light

2 What patterns?

How line, shape, volume,
texture, are accentuated
or altered by light,
depending on its intensity
and the angle at which
it falls (front, back, top,
raking, etc). Patterns
made by light and shadow
on various surfaces.

Fig 65 Eggs

DAPPLED

SPANGLED

MARBLED

SPECTRAL

CHAMELEON

STRIATED

SILHOUETTED

STEREOSCOPIC

INCORPOREAL

MOIRE

CHECKERED

MOTTLED

Fig 66 Cauliflower

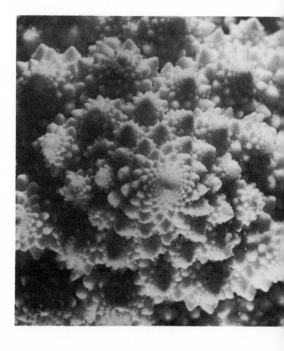

Techniques

Fig. 67 Geometric solid, made of paper, suspended. The various surfaces of the solid sometimes appear convex, sometimes concave, depending upon the angle of illumination

Try drawing/painting one object under different kinds of light. Consider the light-patterns themselves, independent of the object.

Fig. 68 Several pieces of cardboard with holes punched through them (or torn irregularly), placed one behind the other in a frame, leaving a small space between the sheets. A piece of translucent material (e.g. tracing cloth) is put over the frame. Illuminated from behind or from the sides, the holes arrange themselves into patterns and double images

Fig 67 Martin Rossdale

Fig 68

Perforated hardboard or metal, wire mesh of different kinds, and lines or patterns painted on sheets of glass or Perspex (Plexiglass) could also be used to project light-patterns on to a translucent surface.

Light

3 What action?

How different materials
react to light; how light
behaves on moving
objects; how interference
with light produces effects
of movement, distortion,
optical illusions.

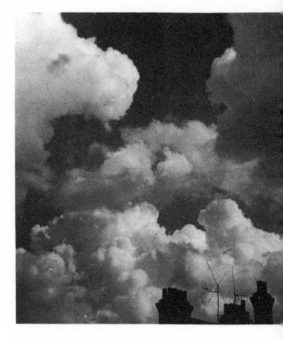

Fig 69 Clouds

REFLECT

FLICKER

Fig 70 Bubbles

SPARKLE

SHIMMER

TWINKLE

FLASH

FULGURATE

RADIATE

REFRACT

PROJECT

DEFLECT

PINPOINT

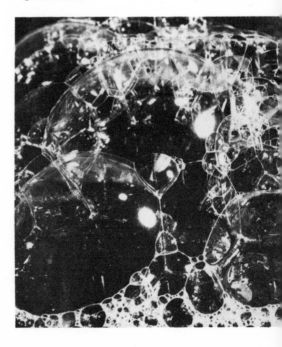

Techniques

Fig. 71 A sheet of metallic foil into which patterns have been cut, placed at right angles to a white surface; lighting arranged in such a way that the foil projects a bright image on to the white surface. The foil then folded, bent, rotated, etc to create changing images

Fig. 72 Very thin lines incised into the black-painted surface of a sheet of curved Perspex (Plexiglass). A sheet of thin translucent material then fitted to the curve of the Perspex, with a small space left between the two surfaces and the possibility of altering the distance between them. When lit from behind with a strong spotlight, a pin-hole camera effect is produced, showing the image of the light bulb and the filament in the centre, at various points along the length of the thin lines. This effect then made sharper or more diffuse by moving the translucent 'screen' nearer or farther away from the black Perspex.

Fig 71

Fig 72

The most likely of your spontaneously improvised 'light-sketches' can subsequently be worked out in detail.

2 Explorations

Having taken stock, to some extent, of your present means of expression, it becomes possible to begin an enquiry into the process of creation — not 'in general' — but as it takes place within yourself.

You are in a room or studio, perhaps surrounded with evidences of past and present work, future projects — pervading it all is a presence which rarely leaves your side: choice. This challenging and exasperating presence never allows you to become quite comfortable. It seems to insist not only upon a continual review of the possibilities within yourself — a painstaking enough process — but also expects you to be ready to abandon, if necessary, all the lessons experience has taught you in order to strike out into totally new directions.

It is this apparent contradiction in timing which makes the exercise of freedom to choose so difficult: on the one hand, choice implies the slow, patient investigation of several possibilities; on the other, it implies suddenly, instinctively coming upon the right answer. Of course, you always hope that the latter will happen, but even when it does, the 'right' solution does not necessarily continue to look right: sometimes, you wish that you had spent more time (or less time) upon a particular idea or a stage of your work.

Why not, then, take *time* itself — as it enters into your own way of working — as your first area of exploration?

Fig 73 Gherardo Starnina *La Tebaide* 14th Century
By courtesy of the Uffizi Gallery, Florence

Time slow. A story told in detail, serialized

Fig 74 Chinese painting: Poem in *hsing-shu* (cursive script)
17th Century
*By Courtesy of the Trustees of the British Museum,
London*

Time fast. Story told in gestures, symbols

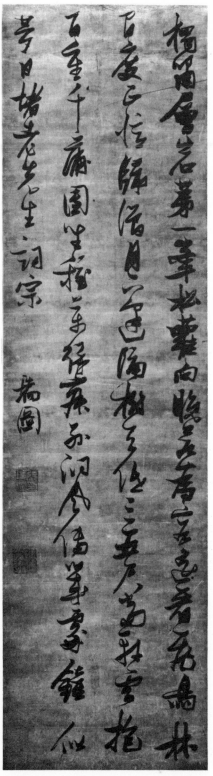

Time

Slow motion

First of all, I find a very simple subject – three oranges – and deliberately stretch out the seeing/thinking/drawing process, break it down into a sequence of impressions. I notice that my eye does not move continuously around each orange but hovers over combinations of *lines* it finds interesting. I put those combinations down as they come. One sheet of paper is not enough, and I begin to think in terms of a long scroll or perhaps a series of interlocking units. Now it is the spaces around the oranges which hold my attention. I draw them as flat, sharp-edged *shapes*. Each time my impressions change I draw another set of shapes. I begin to suspect that one actually sees in serial fashion which only seems to form a whole because the separate instants happen so quickly. I try to prolong the instants. A sense of *volume* now: I enclose strongly-modelled close-ups inside rectangles of different proportions.

Then, *light:* dots come naturally to mind as a graphic means of recording this most evanescent of impressions. The Pointillists did it, printing processes do it, TV tubes do it, computers are being taught to do it (see p. 44), but it is still amazing how simply a judicious sprinkling of spots can create an illusion of light.

Fig 75

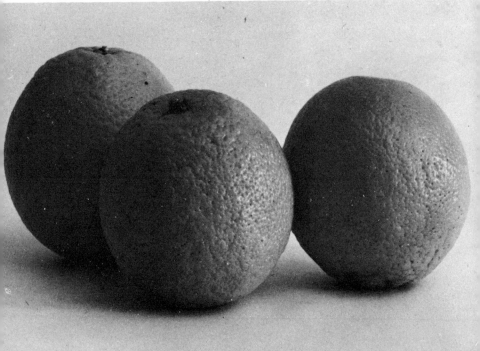

Fig 76 Four versions of 3 oranges, slow motion

43

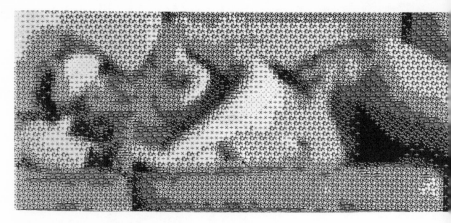

Fig 77 Kenneth C. Knowlton and Leon D. Harmon 'Mural'
1966, 5 x 12 ft
Produced at the Bell Telephone Laboratories, New Jersey

A conventional photograph was scanned, like a TV picture,
and the resultant electrical signals converted into binary
numbers (representing brightness levels at each point).
These numbers then written on magnetic tape provided a
digitized version of the picture for computer processing.
Brightness was quantized into eight levels, from all black
to all white, to represent tonal value for local patches of
picture (100 across, 40 vertically: 4000 in all). Thus each
1/4000 of the picture area is represented by one of eight
possible densities.

Time can be liberation or prison: liberation when you know
you are speaking in your own language, at your own pace;
prison when you are forcing yourself to move too fast or too
slowly, against your own nature. If you feel most at ease with a
slow, analytical approach, it may sometimes be useful to work
out shortcuts and systems whereby your intention can be
realized without the lessening of enthusiasm that comes
through being bored with the means.

Acceleration

I look again at the three oranges and try to find out what happens
to the same subject at high speed. At first, the mind goes blank:
you do not seem to understand what you are seeing if there is no
time to analyze it. But then you find that you can rely to a large
extent on sensation and memory — in fact, the presence of the
subject becomes almost unnecessary.

The different kinds of marks I make on the paper refer back
to my original, slow first impressions, but now I look for the signi-
ficant gesture, the shorthand symbol.

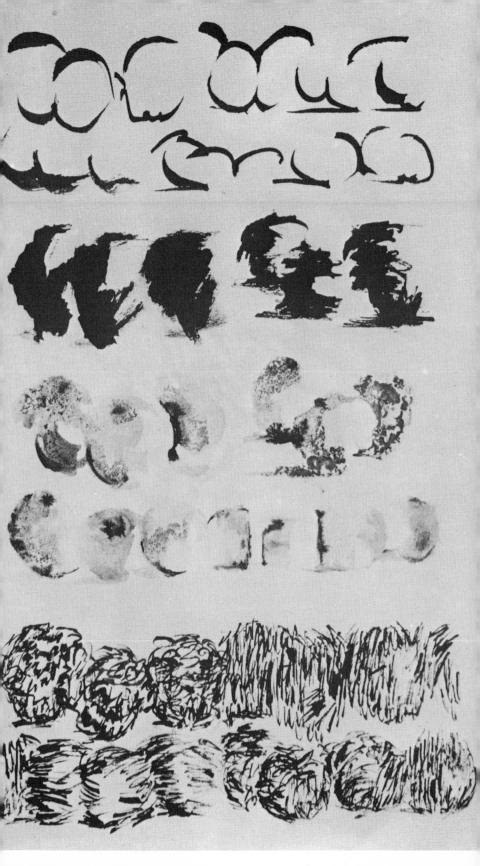

Fig 78 Four versions of 3 oranges, at speed

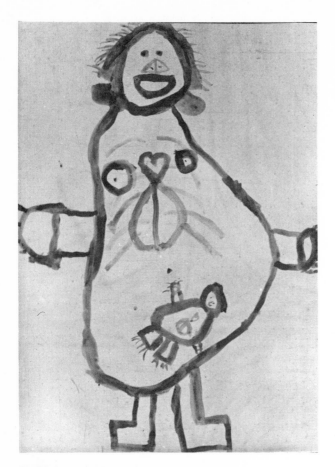

Fig 79 Jonathan Smith (6 years old), Leicester
'Mummy's inside'
*By courtesy of the Sunday Mirror, National Exhibition
of Children's Art 1968*

In accelerating, you are working with something of the same intense concentration as a child. Memory plays a more important part than observation: remembering not so much the object as your emotions about it. Instinctive convictions emerge which may serve as a clue to paths worth exploring in depth subsequently.

Becoming aware of the time factor involved in the act of translating something seen or felt into something *made,* you realize that time can be used as simply another kind of tool. In inventing time-experiments for yourself, this becomes evident in fact rather than in theory. Both the slow and the fast versions of the three oranges suggested further developments in other media. Try slowing down and accelerating your method of working on a variety of subjects or ideas.

Examples: Drawing at top speed, in one session, from a given theme, as many drawings as the theme inspires. Drawing from landscape, and from moving figures, at top speed; keep your hand moving continuously as you draw and forget about neatness — try to *feel* the action of the figures or the inherent rhythms in nature.

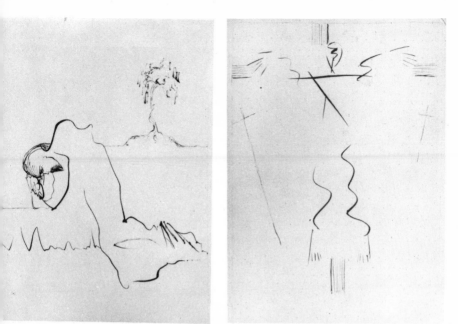

g 80a, 80b Natalie d'Arbeloff: From a series of ink drawings on the life of Christ

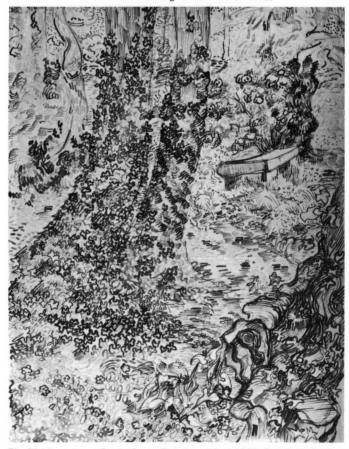

Fig 81 Vincent van Gogh 'Stone Bench and Ivy' 1889. Pen & reed pen
By courtesy of the Vincent van Gogh Foundation, Amsterdam

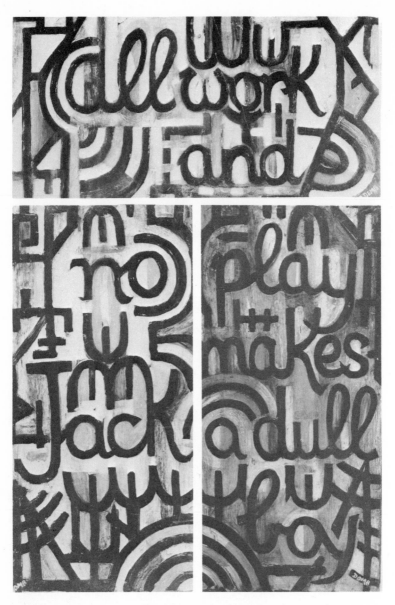

Fig 82 Student (R. Domb) Three-part composition based on writing

Taking a phrase, quotation, or just words at random, as the design basis for a long composition or series of panels. The above example was worked out as three panels of different tonality. The colour was built up slowly in transparent oil glazes over a monochrome underpainting.

The written word could also provide the basis for bold, spontaneous calligraphic designs, done with a brush and ink or black poster paint on large surfaces.

Multiple views of a subject, combined in one drawing, painting or construction. *Slow version:* analysis of line, shape, volume, light — the way one thing becomes another. The subject is placed in the centre of the room; drawings, paintings, or constructions are begun from one position and continued while moving gradually to other angles of view. *Fast version:* same as before, only drawing continuously, without lifting the hand off the paper, and spending less time at each position.

Besides still-life, portrait and figure make ideal subjects for the all-around view. It is important to realize that this approach is not a formula or trick but simply another possible way of seeing. The fact that the Cubists originated the approach does not mean that one is necessarily making 'Cubist' images when attempting a multi-faceted interpretation of something. It is of value only insofar as it can serve as a springboard to individual discovery.

Fig 83 Student (P. Keith) Multiple still-life

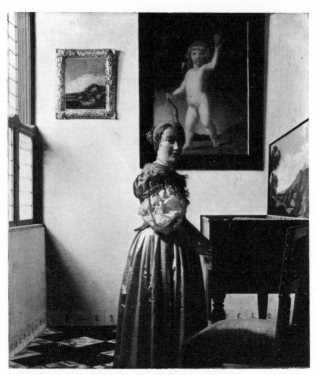

Fig 84 Vermeer 'Lady Standing at the Virginals'
By courtesy of the Trustees of the National Gallery, London

Fig 85 Nepalese painting 'Mandala' 16th Century
By courtesy of the Trustees of the British Museum, London

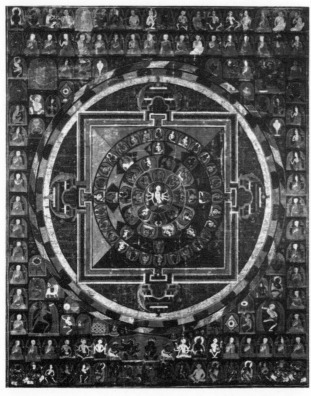

Space

It would seem that one's pictorial interpretation of space is inseparably linked with one's approach to time: if you are working at high speed, intent on leaping over all obstacles standing between you and the crystallization of a particular moment, you are going to find means of dealing with space which are quite different from those which occupy you if you are proceeding with step-by-step deliberation. Consider the ways in which space is interpreted in these three works of art: both the Nepalese painting and the Vermeer, although within very different traditions, give fixed dimensions to space, implying stability, eternity. In contrast, the Turner seems to overflow its boundaries, suggesting movement, the swift passage of time.

Each one of the three expresses fundamental convictions which have shaped their style. This may seem too obvious to point out, until you consider the question of whether you yourself are aware of your use of time and space in your work. It is quite possible that one does not really assimilate any rules of pictorial space which are contrary to one's instinctive concept of time. Finding your natural level is, of course, a continuing process: perhaps this process can be assisted if you can devise questions for yourself, to be answered not in words but in works.

Fig 86 J. M. W. Turner 'Monte Gennaro' Rome 1819
Watercolour
By Courtesy of the Trustees of the British Museum, London

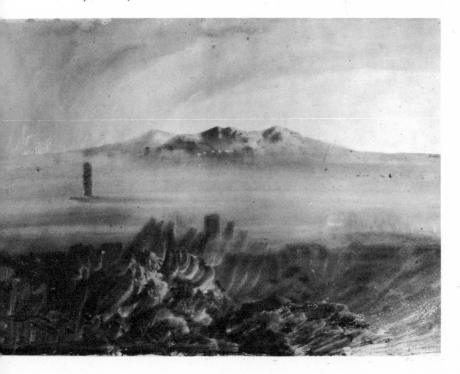

Fig 87a London pub

How do you visualize space? Anything you draw, even only a
dot, implies some kind of space: the dot could be a bump, a hole,
a depression, a stain lying flat on the surface of the paper, a
highlight, etc.

Searching for a tangible illustration of the *fullness* I sense as
space, I find a sheet of foam rubber and paint stripes on it. This
gives me the clue I need and I begin a drawing from the
photograph above, imagining the striped, resilient material as
actually shaping the scene—a continuously undulating surface,
no holes or sharp corners. Objects appear and vanish, mere dis-
placements in the space-fabric.

Fig 87b London pub; space drawing

Fig 88 Striped foam rubber

Fig 89 Student 'Folded Space'

Space can be invented, adjusted to fit an idea. In the above example, space is interpreted as a folded screen decorated with objects, borrowed from the surroundings. This kind of 'seeing' requires an effort, not so much of the intellect as of imagination and sensation.

Another kind of space – shifting, ambiguous – can be created by precise, repetitious measurement: concave becomes convex, surfaces flicker, move, disturb. Drawings on pre-measured surfaces (e.g. ruled paper, graphpaper, dry-transfer shading films) can start off research in this direction. The theme 'reflections' is full of ideas for space-exploration: a mirror image, endlessly repeated, seems to be a symbol of the reality/illusion enigma of space.

Fig 90 Student 'Accordion Space'

Fig 91 Student (A. Richebächer) 'Reflections'

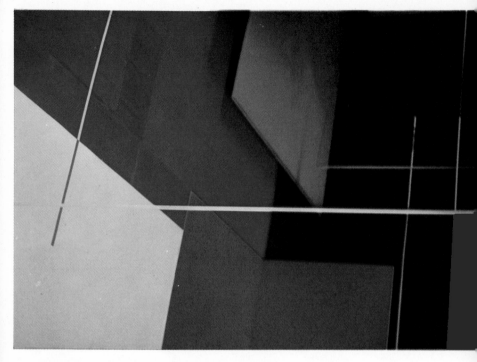

Fig 92 Gerald Duff 'Colour in Space' (environment)

Colour *creates* space merely by its presence, its intensity, its scale. With a minimum of fuss, it sets a mood, establishes distance, depth – even without any drawing at all. The intrinsic power of colour is such that it can suggest almost anything one has in mind, providing one's emotional perception is vivid enough: to represent, say, an icy winter's night by an enormous area of a precisely mixed kind of blue which immediately speaks of winter would require enormous sensitivity – a sensitivity which cannot be learned from any theories on colour mixing and harmony. Exercises in colour relationship, however, are very useful in that they can provide points of departure for more subjective explorations of colour. This is, of course, a vast field in itself; for purposes of this book, I can only touch upon it. (The bibliography lists some helpful works on colour.) But you can devise many experiments for yourself by thinking of colour in terms of *space* and *mood:* if you haven't any actual walls available, try surrounding yourself with large sheets of hardboard (Masonite) painted with household paints in various colour relationships; just experiment with the 'feel' of different colours, on their own or adjacent to each other, uniformly or brokenly applied.

Working on a large scale, the psychological effects of colour become all the more apparent and you find that you are dealing with emotions and sensations rather than mere colours. Formal problems of design become less problematic if you can rid yourself of the idea of 'making a picture', and instead simply play with colours, following your own intuition. Let us say that you have painted three almost wall-sized surfaces red and placed them at right angles to each other. As you stand within this coloured 'room', it occurs to you that you would like a window, or something to interrupt the monotony of the redness. So you paint a white rectangle somewhere on one of the red surfaces. Then you notice that it is not the right kind of white – it doesn't suggest distance – and perhaps you make it a certain shade of grey, or change it altogether. Continuing more or less in this fashion, you realize that colour becomes a tangible experience in which you are participating – perhaps more fully than when you are working on a small scale and there is a separation between you and what is happening on the paper or canvas.

Fig 93 Student 'Winter Landscape'

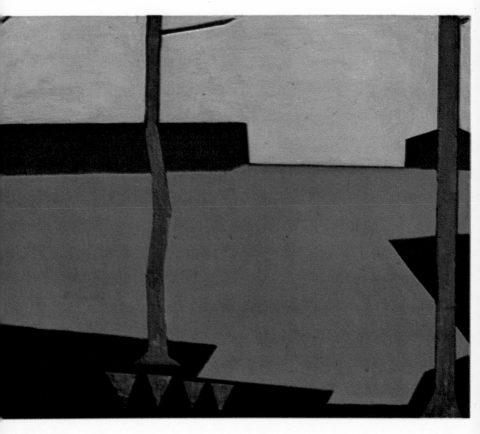

A choice you may at some time feel the need to make is whether to work primarily in two or in three dimensions. To some people, there is no problem here and no question of choosing at all: for them, the move from two or three dimensions represents merely a change of methods. Nevertheless, it cannot be denied that to others, a change over from two to three dimensions (or vice versa) may involve a radical revision, not only of methods but also of intentions. The only way to find out how working in a new dimension will affect you is to test yourself, with an open mind. A good way to explore both illusory and real space is by making constructions (cardboard, balsa wood, wire, etc), using them as models to draw and paint from freely, then making new constructions based on the drawings – and so on, each version developing or clarifying the previous one.

Fig 94 Student: Construction to use as a model for painting

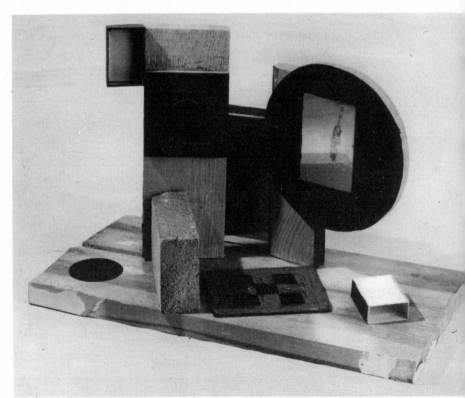

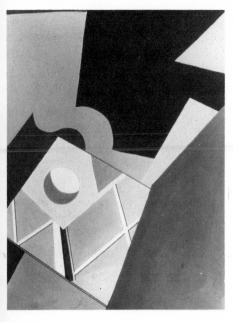

Fig 95 Student (B. Gill) **Fig 96** Student (A. Siu)

Paintings from constructions

Fig 97 Student (P. Keith)

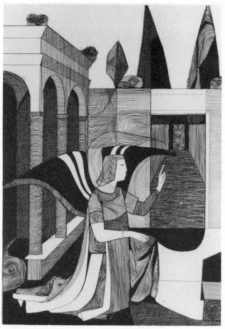

Fig 98 A. Richebächer

Fig 99 A. Richebächer

Fig 100 B. Gill

Fig 101 J. McCallum

Students' line, shape, volume, light interpretations of a
detail from Fra Angelico's 'Annunciation'

Structure

You can look and look at an object from every angle, dissect it, reconstruct it, and yet never come near its essential structure: by this I mean a harmony not easily discerned with the naked eye, sometimes discovered instinctively through a personal geometry. It is impossible to define precisely why an image 'looks right', but one knows when it does. The exploration of structure is, in this context, partly an attempt to bring out of hiding the fundamental images or ideas in yourself, and partly a search for essentials in objective reality. Take, for example, a face – one that you know very well, your own perhaps: when you set out to paint its portrait, you have *two* images to deal with – the one in your mind, and the one your eyes show you. The mental image is as valid as the physical one. You can choose to ignore either one, but the real challenge is to attempt a fusion of the two: this may mean transforming the real image so much that it is barely recognizable; or sacrificing something of your inner vision for the sake of clarity.

Experiments involving measurement, proportion – whether by traditional systems or according to rules you invent for yourself – can help to penetrate external appearances.

You may find it useful at this point to select, from reproductions, a few works of art (those you feel most kinship with), and to study their construction by means of diagrams; or by exercises based on line/shape/volume/light, such as those illustrated on the opposite page. The same masterwork could also be interpreted abstractly, borrowing from the original its proportions, its geometry, but discarding its subject matter.

There are persistent images one collects, hoards until such time as one knows what to do with them. Such an image, for me, is this skeleton torso.

I take its measurements, draw them, trying to find relationships between the idea in my mind and what I see. Gradually, a structure emerges – another skeleton – something dimly familiar, as if I had already seen it or drawn it in the past.

The invented structure takes over and I no longer need to refer to the original skeleton. Other versions follow successively, each one a struggle, as in trying to remember. The image seems to insist on arriving at a denuded kind of solidity, in spite of my attempts to treat it as linear diagram or flat shape. Many more versions will undoubtedly follow before the image finally jells.

Fig 102 From *Anatomical Man* by Silvio Zaniboni, pub. 1956
By courtesy of Alec Tiranti Ltd, London

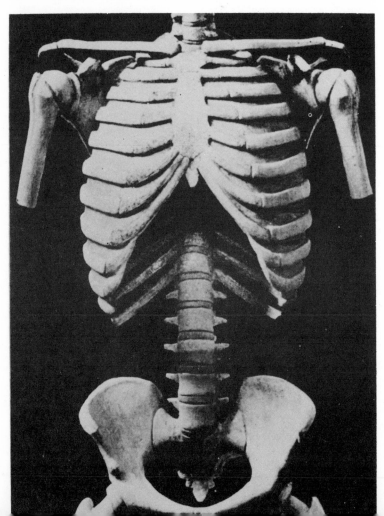

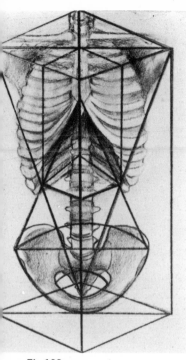

Fig 103

Fig 104

Fig 105

Fig 106

Four phases of the skeleton image

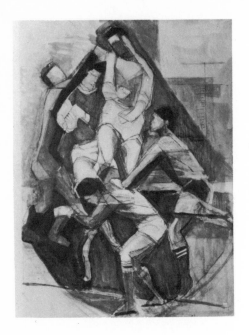

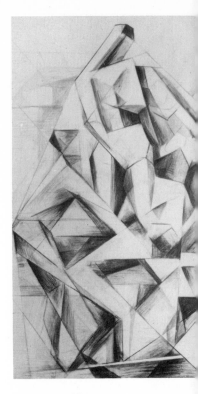

Fig 107a-107b Student (M. Baruch) 'Football Players' structure studies

When working from life, imagine that a dialogue is taking place between the obvious, external appearance of the subject, and your inner perception of it. The problem, then, is not to be intimidated by the insistently loquacious external appearance, yet to extract some essential information from it. Giving form to your inner vision requires enormous patience and attentiveness. The presence of a subject can be a help in this, if you can manage to make the dialogue question-and-answer — not necessarily quiet and orderly, but always full of vitality.

Fig 107c, 107d Student (F. Gautier) Two studies from a figure

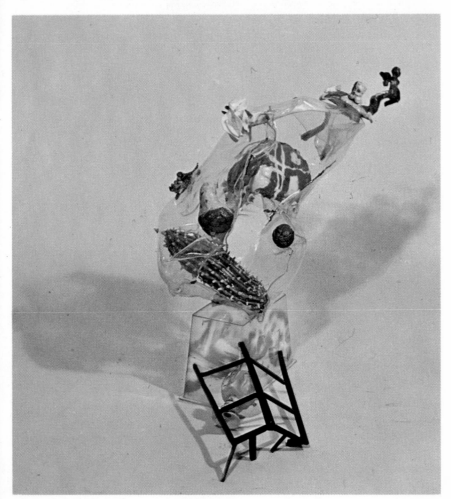

Fig 108 Jerry Pethick 'Desert Flowers' 1966. Plastics

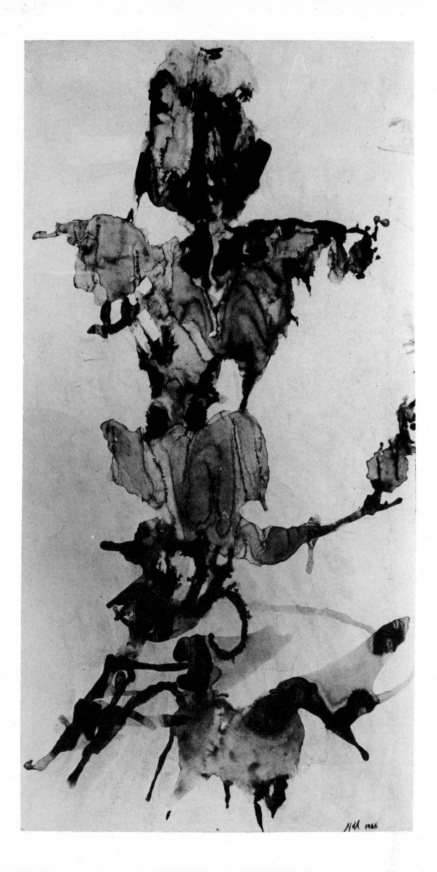

Chance

Nowadays, the acceptance of 'chance' in art—even by such formidable institutions as education and industry—has perhaps resulted in a greater sense of freedom in the artist. But this permissiveness still does not prevent him asking himself occasionally, 'But is it art?' or, 'Is it *me*?' You cannot simply push such doubts aside as examples of old-fashioned thinking, nor can you dismiss the new (or is it so new?) permissiveness as anti-art. Chance itself needs examination, and it may be useful at this point to look into some of the roles that it has played in art in the past, and to draw some comparisons with the present. An exploration of chance which limits itself to techniques is by-passing some important questions—questions which can perhaps be answered only through experimentation, but which it is necessary to raise if one wants to do more than dabble in accidental effects.

Throughout history, the making of art has been strongly influenced by the attitudes prevalent in any particular period or culture towards what can be named the 'unknown'—in which you can include the automatic, the accidental, the magical, the subconscious, etc. When you use the element of chance in your work, you do so with a specific attitude towards this 'unknown', an attitude which is perhaps part of a long tradition. Becoming aware of your own attitude in this respect—by experiment, and by comparison with the past and the present—could suggest completely new directions to you.

For clarity's sake, and to start off experiments, I have divided chance into four categories: chance-magic, chance-inspiration, chance-happening, chance-method. You may not agree with these definitions and find others more helpful: what matters is to penetrate into the territory of chance, or the unknown — and since no maps of it exist, any means of investigation you wish to use are valid. The following eight pages do no more than identify very briefly some basic approaches which can be found in the history of art. A detailed study of these could form the basis of a long-term project — to be undertaken, perhaps, by a group of students.

Fig 109 Natalie d'Arbeloff 'Apparition' 1966. Ink & water

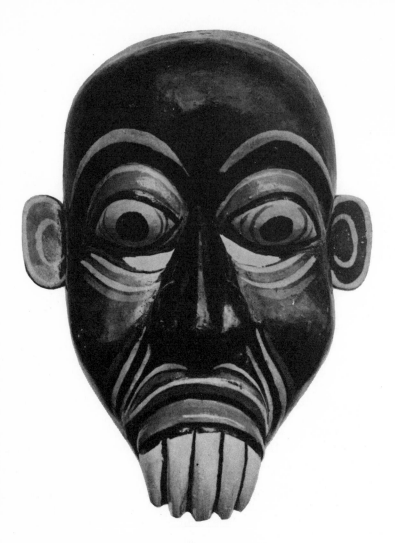

Fig 110 Painted wooden mask, worn by 'devil-dancers' to cure bronchial catarrh or delirious fever. Ceylon
By courtesy of the Trustees of the British Museum, London

Chance-magic

Chance as an unpredictable, capricious outside force, or forces. The art-object serving as an offering, a talisman, or as an embodiment of this force, invoking its support or protecting one from its more destructive tricks. The 'artist' as Medicine Man or Shaman, believing in his power to influence and manipulate chance to some extent, wooing it by the cleverness of his artifacts and rites.
Find examples of what you think is a similar approach in con-

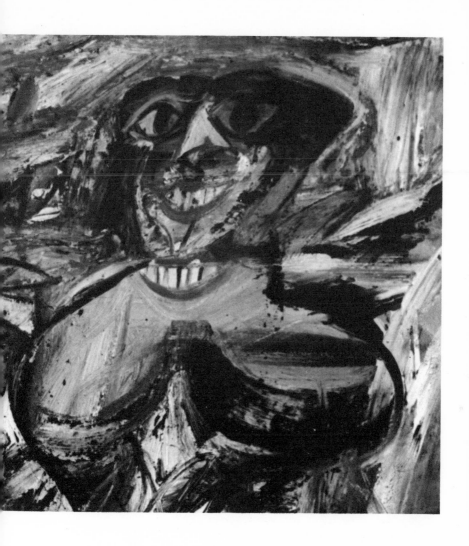

Fig 111 Willem de Kooning 'Woman and Bicycle' 1952-53
(detail)
Collection Whitney Museum of American Art, New York

temporary art. Perhaps it takes the form of belief in the unpredictable subconscious rather than in outside forces; making art becomes a *personal* ritual, a means of breaking away from intellectualism, convention, inhibitions.

Do you feel in sympathy with the 'magic tradition'? Look up relevant examples (primitive masks, amulets, ritual symbols, etc), then improvise: for example, what sort of good luck charm would you make if you really believed you could influence chance with it?

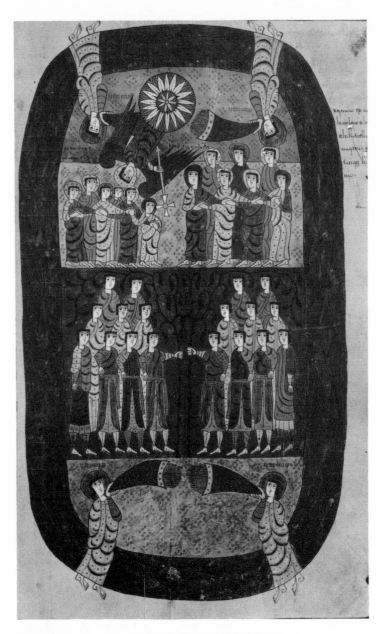

Fig 112 'The Four Angels with the Four Winds' miniature
from Spanish MS, 12th Century
By courtesy of the Trustees of the British Museum, London

Chance-inspiration

Chance as a superior Intelligence, not understood by human
reason. Art as a way of transcribing and illustrating sacred or
occult doctrines; the artist as scribe or medium, abandoning his
will to the dictates of that Intelligence which he believes to be
guiding him. Out of this preoccupation, a hermetic language of
signs and symbols evolves.

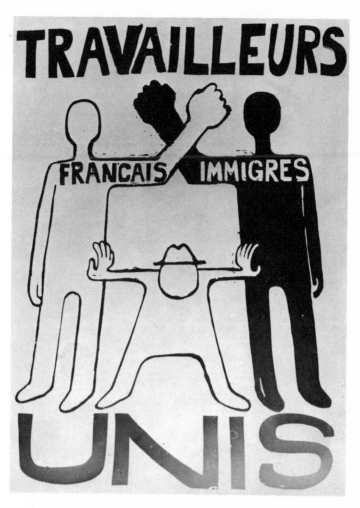

Fig 113 Poster (promoting unity between French and immigrant workers) from the Atelier Populaire, Paris, May 1968
Reproduced by courtesy of the Atelier Populaire, Paris

Can you find any echoes (however distant) of this approach today? The anonymous poster-makers of the Atelier Populaire (during the Spring 1968 revolution in Paris) could perhaps be said to have been inspired by faith in something outside themselves. And the Surrealists — since the start of the movement in the early 1920's — have certainly experimented with 'tuning in' to other voices than those of subjective, conscious reasoning. How would *you* interpret this outlook? For the sake of experiment, choose parts of ancient sacred texts (e.g. Christian, Hebrew, Buddhist, Taoist, Mohammedan, Zoroastrian) which you might feel inclined to illustrate. Then, abandoning yourself to the spirit of the text rather than to the letter of it, draw or paint as *automatically* as you can, rejecting any desire to correct your first responses.

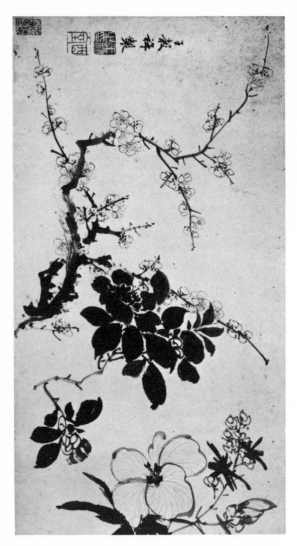

Fig 114 Wang Ku-hsiang 'Flowers of the Four Seasons'
(detail), Chinese, 16th Century
By courtesy of the Trustees of the British Museum, London

Chance-happening

Chance as neither good, evil, divine or diabolical, but simply as
the unforeseen circumstance – or the forces of nature, which
can be controlled only to a certain extent. But the artist must be
in tune with nature and prepared to respond sensitively to the
unexpected. To arrive at this highly receptive state, he must
disentangle himself from intellectual obstacles and theories; he
may then become a Master, from whose hand an 'accidental'
brushstroke is truly an occasion, a happening, a poem.

This approach, with its matter-of-fact acceptance of chance and

Fig 115 Mark Tobey 'New Life (Resurrection)' 1957
Tempera on cardboard. $43\frac{3}{8}"\times 27\frac{1}{4}"$
Collection Whitney Museum of American Art, New York

emphasis on spontaneous expression, is perhaps the most con-
temporary of all – although that aspect of it which implies in-
volvement with nature and an unsentimental self-awareness is a
path less easily followed.

Continuing your exploration of different points of view
towards chance, you might now try giving your undivided
attention to, say, a sound; or to a natural form – e.g. flower,
stone, cloud. Translate your sensations and feelings into spon-
taneous lines, colours – allowing them to simply 'happen', with-
out trying to foresee the result or to make a preconceived image.

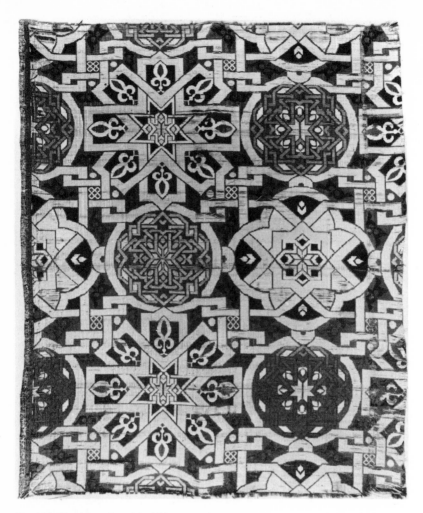

Fig 116 Silk tissue, Spanish, 15th century
*By courtesy of the Trustees of the Victoria and Albert
Museum, London Crown Copyright Reserved*

Chance-method

Chance as the instinct out of which patterns spontaneously
arise if they are allowed to. These patterns can then be organized
and applied to specific objects, according to the canons of a
tradition or the function of an object. The artist as craftsman,
worker, integrated into a particular society which calls upon the
resources of his intuition and skill, and whose traditions he
shares.
There is undeniably a trend today towards re-integrating the
artist with society – for example, among groups working in

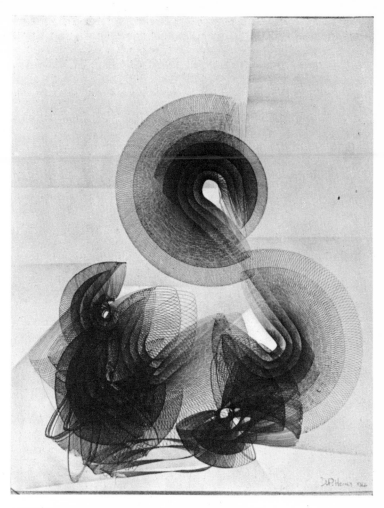

Fig 117 Desmond Paul Henry 'Hyperion' 1962
Drawing produced by an analogue computer (electro-
mechanical) modified by D. P. Henry. The Henry drawing
computer was shown in the Cybernetic Serendipity
Exhibition at the ICA London, August-October 1968
*By courtesy of D. P. Henry, Dept of Philosophy, University
of Manchester*

collaboration with or sponsored by industry – and technology
is continually providing new means of putting chance to work
(viz. Cybernetic Serendipity). Whether the artist/designer nowa-
days actually *shares* the goals of the society for which he works
is another matter: it seems to be more a question of trying to
establish one's own rules and goals, and forming small inde-
pendent societies within society. An interesting basis for ex-
periment here would be your own idea of the specific applica-
tions to which a series of chance patterns you produce might
be put – architecture, furniture design, toys, textile design, etc.
Try transforming some of your 'doodles' into functional articles.

It will have become evident to you that the exploration of chance can be the springboard for a very personal and profound enquiry into the creative process as a whole. One might say that there is no art without chance in some form or other. The key factor seems to be in the amount and *kind* of control the artist chooses to apply to chance, and his attitude towards the rôle it plays in his work. Even the few approaches mentioned in the preceding pages – and you will undoubtedly have discovered others in the course of your own research – serve to illustrate that chance has not one, but many faces.

You can experiment with applying different degrees of control to chance by 'doodling' in line, shape, volume or light, in a variety of media. Starting from one basic random technique – e.g. ink spattering, as in the following example – you might develop the doodle along several directions.

Some examples of accidental art in nature

Fig 118 Spattered ink; vertical lines drawn from each blot

Fig 119 Spattered ink; dry brush drawn across wet blots

Fig 120 Spattered ink; blots connected with horizontal and vertical lines

Fig 121 Spattered ink; blots connected to make solid forms

Fig 118 **Fig 119**

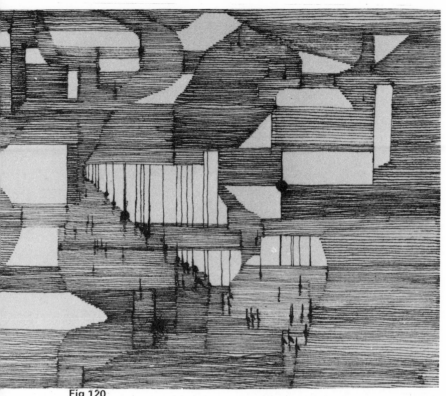

Fig 120
Fig 121

Fig 122 Dry rot

Fig 123 Crystals in rock

Fig 124 Malononitrile (recrystallized). Magnification: 50x

Photomicrograph made with Polaroid MP-3 Multipurpose
View Land camera and research microscope. Photographed
with transmitted polarized light
*By courtesy of Polaroid Corporation, Cambridge,
Massachusetts and* Scientific American *(in which the above
photograph was reproduced in colour as part of an
advertisement for the Polaroid Corp. in September 1968)*

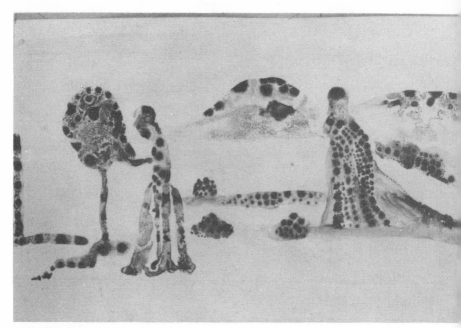

Fig 125 Student (O. Hake) Ink & water
Figurative images allowed to emerge spontaneously while
playing with a technique

Fig 126 Student (P. Keith) Ink & water
Geometric boundaries imposed upon the accidental

Fig 127 Student (A. Richebächer) Ink & water
Many variations are possible with this technique, which
consists mainly in drawing freely with plain water on paper,
then merely touching the water with a brushful of Indian ink,
allowing it to run, tipping the paper, etc. The first layer of ink
can also be nearly washed off the paper by putting it under
the tap in a sink. This leaves a pale wash of ink behind, which
can be added to as above, guiding the accidental effects as
they happen.

Fig 128 Martin Kaye: Ink & water

The enormous number of methods by which 'interesting' chance effects can be produced is confusing and distracting unless you have some kind of scaffolding upon which to base your research. There is the example of nature itself: cloud formations, smoke, icicles, water-patterns, flames, markings on animal, vegetable and mineral forms, etc. (Why is it that *any* chance arrangement in nature, any detail lifted out from it, always seems perfect, complete?) There is the experience of others to serve as a framework; but much more important there is one's own experience.

Your inventory is particularly useful at this point, serving as a rational means of exploring the irrational. Already during its preparation, you will have made notes of methods which can now be re-examined from the point of view of chance, working with complete spontaneity within the limits imposed by the materials.

Wrinkle, rub, slit; spatter, spray, stain, smear; cut, fold, tear, assemble, transform; reflect, deflect, project, filter. Consider each of these words separately (and any other relevant ones you can think of), as a theme for a whole series of experiments, each with its own laws to be discovered. And accept the suggestions a material itself might have to offer – the patterns on wood, for example. And try free-associating with found objects: this might be a class project, carried out in much the same way as the familiar word-association game. A stockpile of found objects is first built up by the class; a student then picks out an object, modifies it or combines it with another – this suggestion is taken up by another student, more objects, and so on until an elaborate random structure has been created by the group. This may, in turn, suggest further developments and applications.

We are now accustomed to – you could even say jaded by – looking for beauty or symbol or excitement in the accidental effect. It is important, it seems to me, to invite the element of vitality and surprise which chance can provide, without sacrificing intention. Sometimes, this might mean *discovering* your intention through chance processes.

3 Concentration

'Limitation is a stimulus to invention in creation.
However, when limiting ourselves we must know when
and where to do so. Limiting ourselves to subjective taste
with arbitrary interpretations or 'free' expressions
is beginning at the end. Nature reveals that limitation
lies at the beginning, in its objective laws or its
methods. With these limited universal laws it arrives
in the end at multivarious or unlimited particular forms.'
Joost Baljeu

(From *Attempt at a Theory of Synthesist Plastic Expression.*
Reprinted with permission from *Structure* 5-2 1963
Amsterdam)

A great part of the time, what we call our creative work is sub-
ject to so many fluctuations, guesses, moods, that we long for
some fixed constants upon which to build. While admitting that
creation is a slow and painful process, we generally mistrust the
arbitrary, unreliable character of our moods and subjective
tastes, and resent having to depend on them as decision-
makers.

But if you break away from this dependence, what can you
substitute as a guiding factor? One possibility is a freely chosen
rule: a decision to concentrate, for example, on a single means of
expression — line, shape, volume, or light — or on a single sub-
ject that you use as a focusing device. If you are strongly moved
by something and you pursue it relentlessly, refusing to be dis-
tracted from it, you develop certain requirements that only
certain techniques can satisfy. Absorption in a subject eliminates
problems of technique by transforming them into specific re-
search towards a specific goal.

This does not make creation any easier, of course; it narrows
its scope and in so doing intensifies its power.

What kind of subject is capable of riveting your attention for a
prolonged period of time, demanding an absolute fidelity which
you enjoy giving it? How do you find such a subject? These

questions can only be answered from personal experience; but I give here an example of a subject which, for me, acts as a catalyst: an apple. Why an apple? Why not a red circle, or a cube? Because the apple is circle and cube and *also* apple; because I often paint apples when I want confirmation, a return to sources; because looking at a particular apple is discipline, and using it in the way I want to use it is freedom. Because for me, the apple is both tradition and beginning. It is also a modular unit with which I can explore relationships, numbers: I prefer using an apple rather than an abstract unit, because I want to leave in all the symbolic associations, the affection attached to real objects, the mystery.

Opposite
Fig 130 Natalie d'Arbeloff 'One. Two. Three. Four. Five. Six. Seven.' 1968. Watercolour

Fig 129

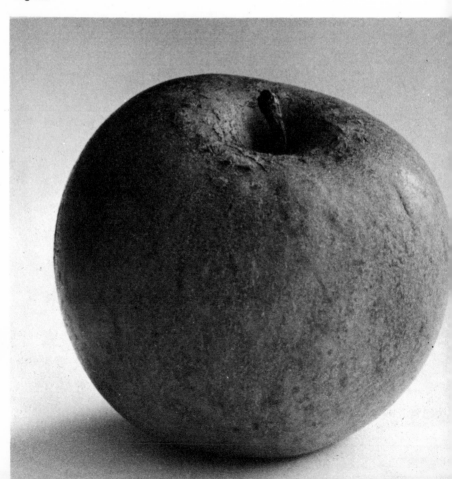

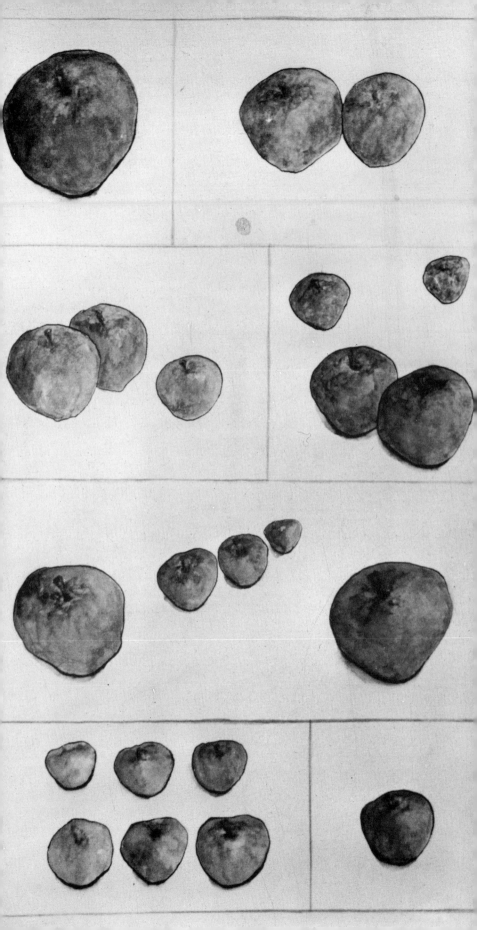

Fig 131 Natalie d'Arbeloff 'Cox's Orange Pippin' 1968.
Monoprint (Printed from glue stencil, as described on p. 27)

In concentrating entirely on a chosen subject, you review again
all the fundamental, formal problems, but they become sub-
ordinated to your central idea. Returning again and again to the
apple as a model, I find that nature is still full of surprises, still the
most original and stimulating teacher. Representation has today
enormously extended its boundaries. There is no need to fear
that it will stultify or strangle the imagination. Our entire con-
cept of nature has changed, broadened, become impregnated

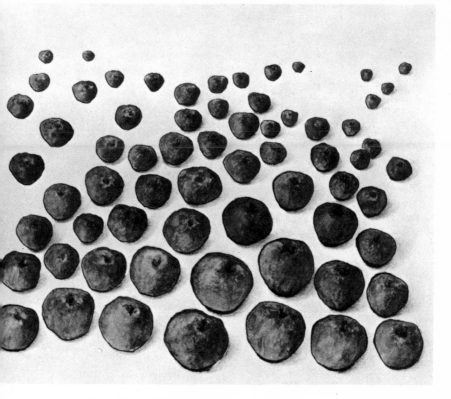

Fig 132 Natalie d'Arbeloff 'Some Apples Are Off the
Ground' 1968. Watercolour
Private collection, London

with the discoveries of the scientists and artists of our time. This
does not mean that our vision must lack freshness – on the
contrary, nature has been freed from the preconceived idea, the
fixed image: we can, if we wish, look at a natural form as if we
had never seen it before.

Painting the apples, I see that the amount of control I want to
exercise consists in their grouping and in the removal of any
other figurative references. The rest – the stimulus of colour and
structure – I want to receive from the subject itself.

Concentrating on any one subject for a prolonged period of time has a double effect: making you hyper-conscious both of its sensuous characteristics and of its abstract qualities. At this point, you may find it necessary to withdraw from the object in order to pursue that particular abstract quality which came most forcefully to your attention. This does not necessarily mean a total rejection of working from nature; there is no need for an either/or attitude, unless you find this absolutely necessary to your peace of mind. My own view is that both are necessary: the singled-out external subject, and the subject which can be simply a certain *kind* of line, or shape or volume; or light and colour itself. It is quite possible to travel freely between these two kinds of perception — perception of the objective, and perception of the non-objective — without neglecting either. Such flexibility requires, above all, a willingness to change your position occasionally and to 'see' in different ways.

The fact that you feel confident and competent on one particular level of creativity may be encouraging, but it can also lead to staleness unless the door is sometimes opened on to other levels, where *unsureness* may be more important than confidence.

You might devote an extended period (say, three months to each) to working consistently within one area at a time: line, shape, volume, light — both as abstract elements and as objects observed in nature. Questions such as those asked in the Inventory can help in that they refer both to the abstract and to direct observation. When you begin to *look for line*, very soon everything you see, and many heretofore unnoticed materials, become potentially 'linear'. The same applies to shape, to volume, to light. Try applying yourself to the exploration of any one of the four, then move on to another point of view, until you have gone full circle. Then start again, this time without making any conscious selection. You will probably find that your perception as a whole has become much sharper and that you have also grown more aware of the one direction which suits you best.

Fig 133 Natalie d'Arbeloff 'Letter' 1968. Incised line on wood

It is important to be as specific as possible in this process – to find out how you yourself can use line, or shape, or volume, or light – to say what you want to say. Some apparently fascinating ideas or methods might, on close examination, turn out to be dead-end streets for you: recognizing this is as necessary as being able to leap boldly into new directions. Interpreting the same subject in more than one way is a great help as it enables you to see what your tendencies are at any particular stage in your creative evolution, and to make a choice among them. When you are working in abstract terms, set yourself specific assignments – for example, elaborating upon questions asked in the Inventory: what patterns? what relationships? what possibility of motion? what intensity? etc.

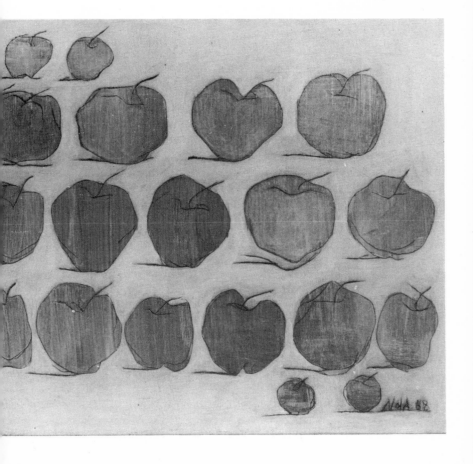

Take *line,* for a start, giving undivided attention to its every characteristic. Begin with the simplest possible means — a pencil line, for instance — and see what happens during the process of playing with it. You might go on to line-rubbings in pencil, as described on p.21; there are countless possible variations and you can find yourself inventing a new method with each rubbing (e.g. placing the string or wire between several sheets of paper under the top sheet, so that the rubbed lines acquire various densities of tone). Then you could try using string itself, on its own or combined with other materials.

Fig 134 String rubbing (two layers)

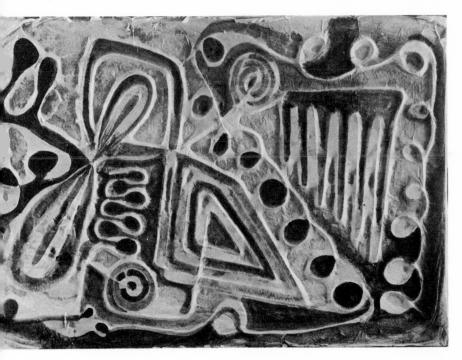

Fig 135 Student (A. Siu) String under tissue-paper

Fig 136 Student (A. Richebächer) String composition

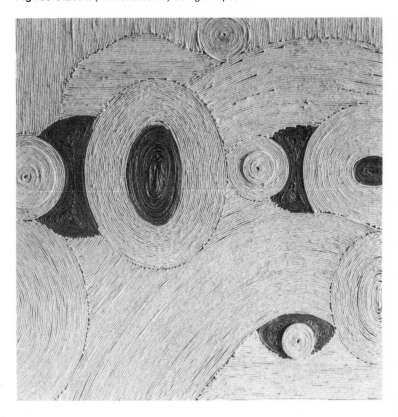

You may find that out of all the methods you explore only one is really necessary to you, and that what you want to say can best be said with only pen and ink. Or, you may discover that what you want to say becomes clearer during the process of manipulating a great variety of tools and materials. In this process, it might be that the concept of the 'unique' work of art becomes less important to you, and that the enjoyment derived from the almost effortless production of innumerable samples is more valuable to you.

Here again, this is a matter of personal choice. One cannot say that it is *better,* or worse, to create spontaneously and prolifically than it is to produce with immense difficulty only one or two works in a lifetime. What matters is to work according to a rhythm one has discovered, through trial and error, to be one's own.

Opposite
Fig 138 David Hockney: No. 12 'Beautiful and White Flowers' Etching/Aquatint. From *14 Poems of C. P. Cavafy* Editions Alecto
By courtesy of Kasmin Ltd, London
Photograph by Deste

Fig 137 String rubbing

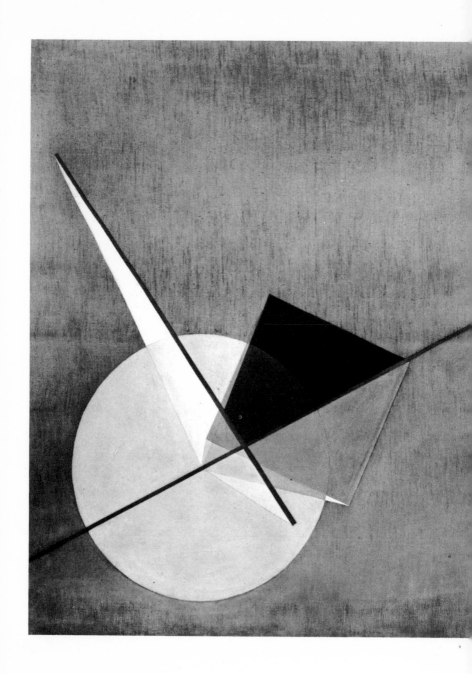

Fig 139 Laszlo Moholy-Nagy 'Yellow Circle' 1921. Oil on
canvas, 135 x 115 cm.
By courtesy of Marlborough Fine Art Ltd, London

'The capacities of one man seldom allow the handling
of more than one problem area. I suspect this is why
my work since those days has been only a paraphrase
of the original problem, light. I became interested in
painting-with-light, not on the surface of canvas,
but directly in space.'

<p style="text-align:center">Moholy-Nagy (1895-1946)</p>

4 Synthesis

Finally, you want to see yourself in relation to others, find confirmation – even contradiction – of your own convictions. Books, museums, galleries, other artists' studios, are holiday resorts from which you hope to return home refreshed and stimulated. But the real work, the synthesis, is carried out when one is on one's own again.

To conclude this book, I have made a selection of work and personal comment by a few contemporary artists – examples of concentration upon the specific areas of visual expression which my enquiry has been concerned with. The contrasts and the similarities between them make them all the more relevant, acting sometimes as challenging question – sometimes as answer – depending upon your own outlook.

Although the most significant synthesis, for anyone involved directly in creation in the plastic arts, is made in terms of images or artifacts rather than in words, it nevertheless seems to be necessary for most of us to define – mainly for ourselves – where we stand or how we are working at any particular stage in our development. The confrontation between one's own notes on approach and procedure and those of others is, to my mind, the most useful kind of communication between artists, at all stages of development. My selection is obviously not a random one. I have tried to include several different approaches to line, to shape, to volume, to light – not necessarily in that order and without labelling them as such, which would be irrelevant and presumptuous. The comments and examples of work by these artists speak for themselves. Within the context of this book, I feel that they are also striking demonstrations of some of the widely different accents with which the four basic languages of visual expression can be spoken.

Harold Cohen

Excerpts from *A propos work in progress,* an edited version of
a recorded conversation. Reprinted with permission from
Studio International June 1968, London.

Until a couple of years ago everything I had done, was in a sense concerned with the problem of drawing; the idea that the mark you make and the surface upon which you make it are essentially different...

After a certain point I think my paintings have become more and more concerned with colour and it's becoming clearer to me all the time that what we think of as drawing and what we think of as colour are mutually exclusive ... As long as one is involved in drawing at all — and for me, line always seems to have functioned in the sense of *out*line ... then colour is essentially something you fill in with ...

The recognition of the non-relatedness of drawing and colour is a major twentieth century preoccupation, but colour is an impossible *main* preoccupation for anyone involved in figuration ...

You start off thinking: Well, all I've got to do is to stop the thing being recognizable ... Then you realize that you can create a landscape, I mean this specific landscape, without painting trees or anything. The mind needs very little to pin a figurative reading on ... I've found finally one line is enough to establish a spatial reading that goes against colour. Then why is one interested? I don't know why I am interested in colour ... The logic of the situation is what is so pressing, the moment when you recognize that colour always has been one of the most expressive parts of what you've been doing. Yet I'd always reach the point in a painting where it was a question of ... should I make it red or should I make it yellow? ... I wanted to arrive at a state where the colour was as unequivocal, as positive, as unarbitrary as the drawing. The moment you're that interested and you start your exploration it becomes increasingly obvious that until you have stripped everything else off, you're never going to know what colour is going to do or what it's capable of ...

Leaving aside the technical problems, the biggest problem for me over the past couple of years is that once you do eliminate the drawing, how the colour is going to behave is totally unpredictable because you don't really have the experience ... I find with what I'm doing now you put down two colours, and what you see at the end doesn't really have much to do with either of them ...

We've known for a long time that if you put down one area of colour next to another area, something peculiar happens at the edge, but nobody's ever done very much about it, except do it at the edge. And I think in a way what I'm doing is taking that edge

Fig 140 Harold Cohen 'Shimmer' 1968. Acrylic on canvas,
102″x118″
Collection of the artist

and putting it all over the canvas, and it really does become very
peculiar then.

The essential thing about the dots for me is that they go all
over the surface of the canvas in a completely undifferentiated
way . . .

I'd like to get to the state where the painting disappears and
just leaves colour.

Michel Seuphor

Translated from the article 'Le Système et la Règle'
Reprinted with permission from *Leonardo* April 1968,
Pergamon Press, Oxford.

The system is to the academic philosopher what the rule is to the man of common sense. The system tends towards hegemony, towards a kind of intellectual imperialism. It is a mould. The system does not permit dialogue, it prefers to remain monolithic and unchallenged. To challenge it is to be pitilessly conquered by it.

The rule, on the other hand, has nothing of the machine. One can manipulate it. One is not manipulated by it: it adapts itself to our usage. It does not pretend to be complete in itself, as the system does. It is merely a detail of our way of life, but a detail which accompanies us, guides us. There is always a way of bending the rule a little, of straying from it as from an ideal path, but still keeping it in sight. One can say to it: perhaps . . . whereas the system demands an unequivocal yes or no, without nuances.

The straight line, which I adopted a long time ago and to which I have remained faithful, is to me a way of life, a kind of voluntary poverty. It is not a method, as some have believed. It suggested itself to my hand almost organically, at the end of a long evolution of linear play. It is not, properly speaking, a technique: rather, the reduction of plastic means to their simplest expression, that which appeared to me one day as their most natural unity — the straight horizontal line.

If I obey my rule it is not on principle or in blind submission but for pleasure. If I have never abandoned it for sixteen years, it must be because this pleasure constantly renews itself. I know now that it can vary infinitely — the pleasure of my rule is inexhaustible.

My rule is not very strict, not at all rigid. I never apply it *absolutely*. The line is straight, certainly; horizontal, always — but it must be sensitive in every part. I do not conceive of it except as drawn by the lifted hand without intervention from a material ruler. However, I insist that the line be straight, as straight as possible: the string vibrates only when tense. It is the rule which guides me to the very core of the pen. It has become integrated with my hand, it is within my fingers, in the blood which circulates in my fingers, transformed into the long, thin stream of black ink.

When I go for a walk I stop where I like, allow the sky to envelop me, let time flow without trying to fill it. And I see that this kind of time, this interval, is more alive than that which we crowd with activity.

My line is never alone, it joins others, parallels, its equals. It is a society of lines. My population varies a great deal in density. Sometimes there are feasts, when I introduce colour by means of

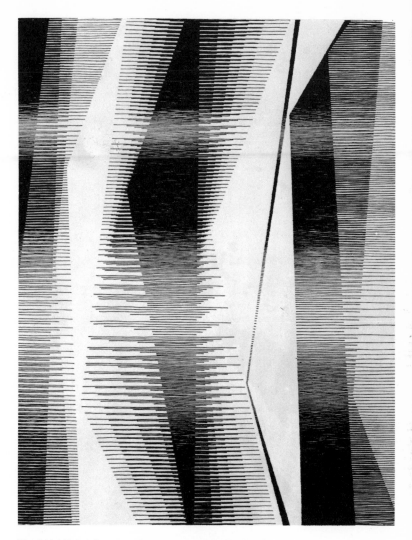

Fig 141 Michel Seuphor 'Rythmique' 1962, 67 x 51 cm.

pasted papers. But light is always celebrated. It is omnipresent, bodiless. It lives between the lines. It is light which sings. And the lines accompany it, sustain it by their modulations. They temper the flame. In fact, the lines serve only to limit the extent of light, but in so doing, they create movement within it.

L. Alcopley

Excerpts from the article 'Drawings as Structures and Non-Structures'. Reprinted with permission from *Leonardo* January 1968, Pergamon Press, Oxford.

My drawings may be classified as *structures* and *non-structures.* The former are conceived as compositions or arrangements of lines, while for the latter I make no such attempts. In the non-structure drawing, the element of the unexpected and of the accidental plays a dominating role. As in life, the accidental seems to come from nowhere, but has a peculiar strength in pointing to a new direction or forcing itself upon one.

The automatic, which is not identical with the accidental, is done – as the term implies – without conscious thought, and seems to be essential in many non-structure drawings. The elements of the unexpected, the accidental and the automatic enter to some extent into the process of drawing structures, but these elements do not appear to dominate them.

Structures of signs . . . spring from my personal experience of nature, and the special phenomena with which I am concerned in my scientific work. For more than three decades I have been an experimental biologist and therefore have lived in a world of the smallest natural phenomena. At the same time, I have tried by the continuous practice of drawing, to catch some of their aesthetic and expressive values until finally the setting of lines crystallised into new signs. They correspond to certain thoughts which I can only express in the movement of these lines . . .

Attempts to give a naturalistic picture of parts of nature, only accessible to us by the use of microscopes and other fine instruments, is of no interest to me . . . I do not deny that forms which I have seen with the aid of instruments . . . may, in some abstracted way, become elements in my drawings . . . The basic vision in my work as related to science is the flow or motion of elementary spatial processes which I experience in my scientific activities.

The holding together or so-called bonding of atoms of carbon can lead to chains of giant molecules. The shape of these chains is due to the assemblage or arrangement of polymer chains.

In these molecular arrangements the distribution of space plays a significant role in their structures.

Fig 142 L. Alcopley 'Drawing as a Structure of Signs'
1967, 22·8 x 15·1 cm.

The conception of space in my pictures is filled with elementary processes, similar to those of inanimate origins . . .

In my work, letterless writing or writing without words becomes drawing, in which the imparting of motion has as its actuating force the experience of the unsayable. It is as if a breath would form the world in which all is moving and alive.

Derrick Greaves

Excerpts from 'Seven Notes from a Notebook', December 1968. With permission from Derrick Greaves.

1 . . . Meaning? Meaning so very often seems to be merely opinion. Opinion is useless in painting. Like comment it is misplaced there.
Objects, recognizability, objective reality, impassivity, is better. 'It is' is better than 'it is meant to be'.
I am in my objects only in choosing them in the first place. The painting of them in colour, tone, etc is so much carpentry or plumbing which is done, like them, as a job; well or badly. I exist more in the gap between the canvases when they are joined, for here pure intuition rules. This is where I make a stab at silence, gaiety, sex, sadness . . .

2 Making facts out of facts = painting/poetry.

3 I have learned — am still learning — much from van Gogh . . .In his urgent desire for clarity he pushes form towards its extreme expression, interrogating, as he does so, each formal necessity — colour, line, etc the hope that true identity/content will be nakedly revealed. The best final images to emerge from this mental trouncing are not just 'single' however, but 'laminated'. Multi-layered and potent . . .

4 The canvas — wall or membrane?

5 . . . I used constantly to jot down ideas in a book in case I forgot. Now, I prefer to take the risk of forgetting. The ones I don't forget are the ones worth doing something about.

6 Cultivating a capacity to begin again — and again. It seems to me to be absolutely necessary to go on re-evaluating one's own basic vocabulary. In the case of painting, line, colour, interval etc all the ingredients need constant re-appraisal to avoid tacit usage . . . As one goes on, of course, one changes. I find I need less of most things.
Not the revolver, nor the explosion. A picture of the trigger is sufficient.

7 In order to speak any language of the spirit clearly, it is necessary to be as practical as possible.
Just as it is possible under pressure to forget simple enjoyments, so it is easy when working to forget to use what is at hand, available, as practical reference. Solutions or, at least, clues are always at one's elbow. In the same way that the uneventful is nevertheless an event as soon as one is able to withdraw

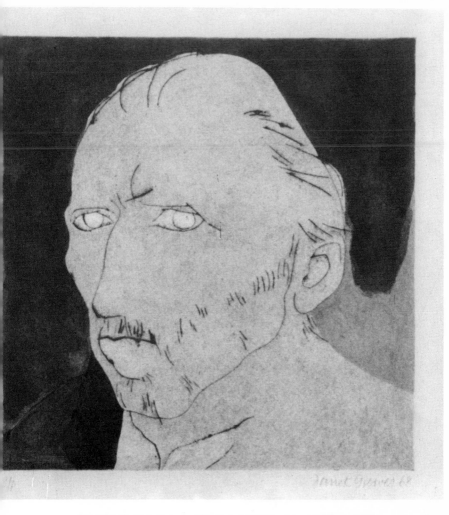

Fig 143 Derrick Greaves 'Portrait I' Etching in an edition of 50
*From Derrick Greaves' 'Homage to Van Gogh' Exhibition at
the Curwen Gallery, London 1968*

enough to be aware of it. The more one fails to use what is readily available in starting a thought-painting process, the more uneasily esoteric the result must be. As paintings breed other subsequent paintings all too easily, the first esoteric results multiply (escalate!)
False loneliness ensues.
At this point, painters console one another, form groups, etc.
I am trying in a world of education and distraction not to ignore the close-at-hand. I have come to believe in a process of working to include 'natural return' to available ordinary things.

Francis Bacon

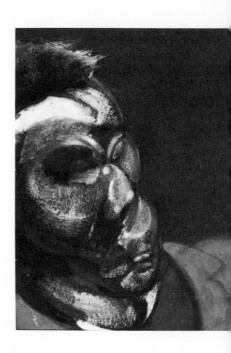

Excerpts of comments by Francis Bacon from interviews
with Bacon by David Sylvester for BBC Television May 1966.
Published in the catalogue for the Francis Bacon exhibition
at Marlborough Fine Art Ltd, London, March-April 1967.
Reprinted with permission of David Sylvester.

I want a very ordered image but I want it to come about by chance.

I think that the mystery of fact is conveyed by an image being made out of non-rational marks. And you can't will this non-rationality of a mark. That is the reason that accident always has to enter into this activity, because the moment you know what to do, you're making just another form of illustration.

I think that great art is deeply ordered even if within the order there may be enormously instinctive and accidental things. Nevertheless, I think that they come out of a desire for ordering and for returning facts on to the nervous system in a more violent way. Why, after the great artists, do people ever try to do anything again? Only because from generation to generation, through what the great artists have done, instinct changes, so there comes a renewal of feeling of how can I re-make this thing once again more clearly, more exactly, more violently.

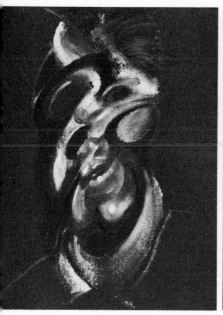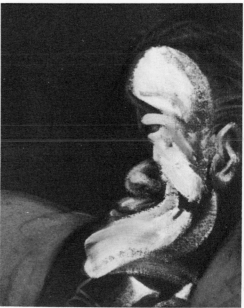

Fig 144 Francis Bacon: 3 Studies for a Self-Portrait, 1967,
each 14"x12"
By courtesy of Marlborough Fine Art Ltd, London

I think art is an obsession with life, and after all, as we are human beings, our greatest obsession is with ourselves. Then possibly with animals, then with landscapes.

I don't want to avoid telling a story but I want very, very much to do the thing that Valèry said – to give the sensation without the boredom of its conveyance. And the moment the story enters the boredom comes upon you.

. . . an illustrative form tells you through the intelligence immediately what the form is about, whereas a non-illustrative form works first upon sensation then slowly leaks back into the facts. Now why this should be, we don't know. This may have to do with how facts themselves are ambiguous, how appearances are ambiguous, and therefore this way of recording form is nearer to the fact by its ambiguity of recording.
What I want to do is to distort the thing far beyond the appearance, but in the distortion to bring it back to a recording of the appearance.

Vasarely

Excerpts from the article 'Vasarely: a survey of his work',
by Jean Clay. Reprinted with permission from *Studio
International* May 1967. The quotations cited are by
Vasarely, results of his conversations with Jean Clay.

The abstract was only revealed to me in 1947 when I was able to
recognize that pure form and pure colour could represent the
world . . .

What was a yellow apple in a composition in the past if not
above all a yellow circle? But if I just paint a yellow circle and
not an apple, it could just as well be the sun . . . I accomplish and
encompass more. At a period when mankind has extended his
knowledge to cover both macro- and micro-cosmos, how can
an artist get excited about the same things that made up the
day-to-day world of the painter of the past, restricted as it was to
what came within his immediate sense range — his house, the
people he knew, his garden, the landscape, his town? . . .

Time deposits a patina which tampers with the essence of a
work. Only re-creation according to given constants will enable
people in twenty or fifty years' time to experience the exact
feelings of the artist. If art in the past has *felt* and *made*, it will in
the future *conceive* and *have made*. The myth of the unique
work must go . . .

Putting ten or twenty thousand stimulating works of art on
children's and young people's walls is not only feasible but
certain and will achieve the double purpose of filling both
physical space (the city) and mental space (the public mind).
That is why I base the components of my technique on con-
stants: precise colours, measurable geometric curves, size,
harmony, scale, all of which can be easily reproduced. I do a
small-scale model on the basis of which one or several canvases,
a tapestry, fresco, panel, or a film or television design can be
made. It is usually unnecessary for me to touch these secondary
jobs. I have three full-time assistants; thanks to them I am able
to put in forty or fifty hours a day . . .

For the moment I am exactly in the same position as an im-
pressionist. I look at one of my preliminary prototypes. That red
is too strident. The old painter in me rises. I change it. It's almost
a physical thing. A dissatisfaction.

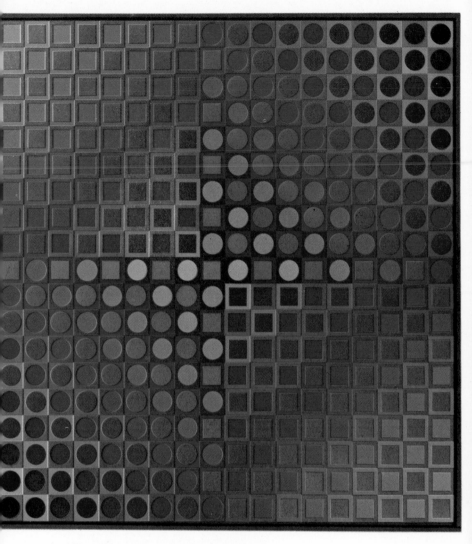

Fig 145 Vasarely 'Boglar III' 1966, 76 x 76 cm.
By courtesy of Galerie Denise René, Paris

Until we have a new system, we shall be reduced to this kind of mysterious instinct. But one day I am sure we shall have a science of painting. A certain orange will give you truculence. A certain grey and a certain green, sadness. Already some scientists are trying to invent a perfect creative machine. I am sure they will succeed. . . .

What I want is a world-wide folklore where each person, by following the same rules, can express his own individuality.

Euan Uglow

Excerpts from comments by Francis Hoyland in the catalogue
to the exhibition 'Survey '66 : Figurative Painters', at the
Camden Arts Centre, London, April-May 1966. Reprinted
with permission from Francis Hoyland.

Although Uglow must work to a fairly strict system, he is un-
willing to talk about it as he feels that his paintings should be
left to speak for themselves. And this decision is consistent with
the uncompromising impression that his pictures give me.

However, I cannot help speculating about this system and as
far as I can make out it involves some sort of manual measure-
ment . . .
Uglow's pictures look to me as though they may be measured
inwards by some process involving the division of a large pro-
portion stretching across the width of the canvas.

Any ruthless system of measurement seems to imply an even
surface stretching across the canvas with an equal degree of
tension. This rules out the sort of differentiated touch that we
find, for instance, in Venetian painting and in Rembrandt — a
touch that records the progressive accumulation of a series of
spatial and tactile sensations.

The space in Uglow's pictures is systematically constructed
in the same way as in some fifteenth century paintings — we are
forced to *read* it, rather than to experience it.

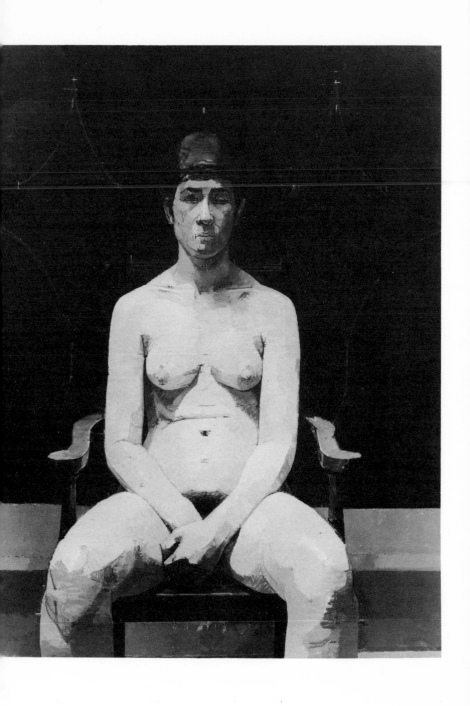

Fig 146 Euan Uglow 'Green Nude' 1964-65. Oil, 36″ x 45″
Photograph by John Webb

Jack Smith

Excerpts reprinted with permission from *London Magazine*
March 1965. Included in the catalogue to the Jack Smith
exhibition, Grosvenor Gallery, London, March-April 1965.

I think of my paintings as diagrams of an experience or sensation. The subject is very important. The sound of the subject, its noise or its silence, its intervals and its activity. When I talk about the sound of the music of the subject I'm not always thinking in terms of a symphony, but groups of single notes.

The closer the painting is to a diagram or graph the nearer it is to my intention. I like every mark to establish a fact in the most precise, economical way.

More and more do I find that activity of different kinds is essential in the painting — I want it to be as complex as a symphony; to keep the surface as flat as possible, letting it have visual space or eye dance, but no impressionist, cubist or continued space. I would like the surface to be as remote as Vermeer.

Certain forms seem repetitive over a number of years as though there are collective forms which have a definite meaning. Diagrams of the sea — periscope divisions. Measure the sea. The eye is a ruler. A new language must be made, sharp and clear. A form needs to be developed for each individual experience. We tend to see things separately, hence my interest in multiple vision. An enormous number of successive experiences within one painting. A persistent melody of undertones and overtones.

Fig 147 Jack Smith 'Inside and Outside. Roundabout'
1964, 48″ x 48″
Collection Misha Black

Mary Martin

'On Construction'. Reprinted with permission from *Structure*
5-2 Amsterdam 1963.

Construction

A thinking making process, not necessarily three-dimensional. A drawing can be. Some three-dimensional assemblages are not. So that assembly would appear to be a by-product, not the key. Internal logic is the key.

Orthogonal construction

A working process. It is practical to make orthogonally, but it is impossible to create a purely orthogonal structure. One dot on a page is important in itself. If there is a system of dots on a page, it is the relationship between them which becomes important. A straight line, even by itself, can suggest a square, or a circle. A square can suggest a circle and vice versa. A plane can suggest a parallelepiped, or a movement. The juxtaposition of two planes of any related dimensions can suggest a relationship of diagonals in space. The right angle contains the possibility of evolution because it has these suggestions. In other words, the orthogonal contains the non-orthogonal. The reverse can also be true.

The right angle versus the curve as a means

No opposition here. Each contains the other, therefore either may be used, or both. The right angle is not more static than the curve, the curve more dynamic than the right angle. Each may be either. It is the expressive power of the artist which invests the construct with life, the lack of it which produces deadness.

Fig 148 Mary Martin 'Permutation of Five' 1967. Stainless steel, painted wood on formica and wood, $19\frac{1}{2}"\times19\frac{1}{2}"\times4"$
By courtesy of Axiom Gallery, London

Ted Sebley

Notes from a conversation. 1968.

I always began with a clear mental picture of something —
generally a still-life — then went about looking for the right
objects, colours.

I wanted the objects to be *there* while I painted so as to verify
my mental image, but to take from them only what I needed.

When I had found the subject and arranged it, I would first of
all do a quick, 'hot' version of it — colours thickly laid on with a
palette knife — and get all that out of my system.

Then the real work began. Pared-down drawing, suggesting
volumes by slight, careful distortions; elimination of strong
shadows; colours borrowed from the subject but distilled,
purified, meticulously mixed and uniformly applied.

I wanted to be in absolute control over every square inch of the
canvas, every brush stroke. Imagination came into it in the form
of the original mental picture.

I did not *decide* to give up painting. Photography came my
way by chance and stuck with me. I became gradually more and
more involved with it; it seemed to offer the means of attaining
the degree of control I wanted over my subject while still allow-
ing room for imagination.

Now that photography has become my profession, my
attitude towards it is one of familiarity, friendship, loyalty. I can't
say the same of my feelings about painting. These are more
emotional. It is difficult for me to put them into words and I don't
know if I shall ever want to try putting them into paint again.

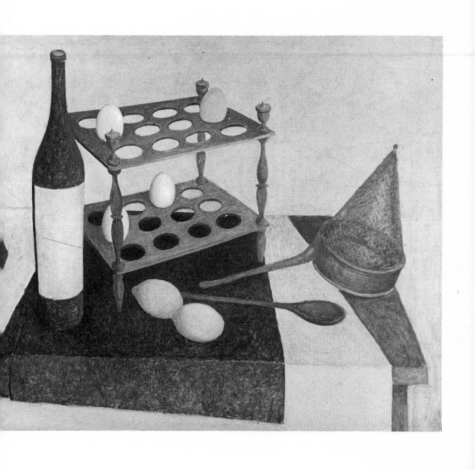

Fig 149, Ted Sebley 'Still Life' 1953. Oil on canvas
Collection of London Transport

Roy Lichtenstein

Excerpts from 'Talking with Roy Lichtenstein', an interview by John Coplans. Reprinted with permission from *Artforum* 5-9, May 1967 New York — Los Angeles.

Q. *How do you do your paintings?*
A. I just *do* them. I do them as directly as possible. If I am working from a cartoon, photograph or whatever, I draw a small picture — the size that will fit into my opaque projector — and project it on to the canvas. I don't draw a picture in order to reproduce it — I do it in order to recompose it. Nor am I trying to change it as much as possible. I try to make the minimum amount of change, although sometimes I work from two or three different original cartoons and combine them. I go all the way from having my drawing almost like the original, to making it up altogether. It depends on what it is. Anyway, I project the drawing onto the canvas and pencil it in and then I play around with the drawing until it satisfies me. For technical reasons I stencil in the dots first. I try to predict how it will come out. Then I start with the lightest colors and work my way down to the black line. It never works out quite the way I plan it because I always end up erasing half of the painting, re-doing it, and re-dotting it. I work in Magna color because it's soluble in turpentine. This enables me to get the paint off completely whenever I want so there is no record of the changes I have made. Then, using paint which is the same color as the canvas, I repaint areas to remove any stain marks from the erasures. I want my painting to look as if it had been programmed. I want to hide the record of my hand . . .

I use color in the same way as line. I want it over-simplified — anything that could be vaguely red becomes red. It is mock insensitivity. Actual color adjustment is achieved through manipulation of size, shape, and juxtaposition.

Q. *Did you find or invent the brush stroke image?*
A. Although I had played with the idea before, it started with a comic book image of a mad artist crossing out, with a large brush stroke 'X', the face of a fiend who was haunting him. I did a painting of this. The painting included the brush stroke 'X', the brush, and the artist's hand. Then I went on to do paintings of brush strokes alone. I was very interested in characterizing or caricaturing a brush stroke. The very nature of a brush stroke is anathema to outlining and filling in as used in cartoons. So I developed a form for it which is what I am trying to do in the explosions, airplanes, and people — that is, to get a standardized thing — a stamp or image. The brush stroke was particularly difficult. I got the idea very early because of the Mondrian and Picasso paintings which inevitably led to the idea of a de Kooning. The brush strokes obviously refer to Abstract Expressionism.

Fig 150 Roy Lichtenstein 'Yellow & Green Brushstrokes'
1966. Oil and Magna on canvas, 36″x68″
Collection of Robert Fraser
By courtesy of Leo Castelli Gallery, New York

Frank J. Malina

Excerpts from the article 'Kinetic Painting: The Lumidyne
System'. Reprinted with permission from *Leonardo* January
1968, Pergamon Press, Oxford.

I am grateful to Dr Malina for his permission to include
these long extracts from his article which I felt would be of
special practical value to individuals or schools who are
interested in exploring the possibilities of light in motion,
but have as yet no standard system from which to begin
their research. **Natalie d'Arbeloff**

There are aspects of man's environment and his conceptions of
it involving light from the sun, motion and changes of colors
with time that painters have long wished to express in their
works of art. But it was not until the last century when the dyna-
mo for the generation of electricity was invented that practical
means became available to the painter to enter into this domain
of visual experience . . .

Kinetic art includes visual artifacts of three-dimensional or
constructional type with mechanical motion of solid bodies . . .
The second major domain of kinetic art comprises the use of
cinema equipment to create pictures of changing composition
and color projected on to a framed area . . . Norman McLaren's
work directly on virgin film is a notable example of this tech-
nique. Finally, there is the whole range of the less familiar
kinetic 'painting' systems, utilizing a translucid screen . . . Three
principal kinetic painting systems have been devised for pro-
ducing a pictorial composition on a translucent flat surface that
changes with time without resorting to the projection of light
through film in a darkened room.

The oldest system, developed since 1905 by the American
Thomas Wilfred, makes use of rotating forms made from materi-
als such as mirrors and polished metals (1). These reflect chang-
ing light patterns on to a translucent pictorial surface. Colors of
the patterns are determined by transparent colored materials
which intercept the light source before the light strikes a reflect-
ing surface.

In the second system, which I developed in 1956, the main
composition is painted on a fixed, transparent plate (the Stator),
and a design is painted on a rotating transparent disc (the
Rotor). Light from incandescent bulbs or fluorescent tubes is
transmitted directly through the Rotor and then the Stator on to
a translucent plate (the Diffusor) to produce a picture combin-
ing light, color and movement. I have called this the Lumidyne

system. (It was not until after I had exhibited my first kinetic paintings at the Galerie Colette Allendy in Paris in 1955 that I became aware of the work of Wilfred (2, 3).

The third system makes use of color changes brought about by the direct transmission of light through polarizing materials, one of the sheets being rotated. The color changes are caused by the introduction of materials between the two sheets that produce birefringent colors.

The Lumia of Wilfred creates a picture the composition and colors of which change with time; my Lumidyne has movement and changing colors within a fixed composition; and the kinetic paintings utilizing polarizing materials have either a fixed or a changing composition together with changing colors.

The period of time for the repetition of the picture with these systems varies from one or two minutes to a cycle of infinite duration. The cycle for the Lumidyne system with its fixed composition is not readily discerned, even when its period is only one minute, because of the complexity of the movement that the artist can introduce.

Work in the field of kinetic painting consists of two distinct phases. The first comprises the construction of a compact system capable of producing an image with light and movement. There is no reason to believe that the three systems I have mentioned are the only possible ones, as a matter of fact, several variants of these systems are now being used by artists . . .

The second phase consists of creating a satisfying aesthetic visual experience on the translucent surface. It is not difficult to produce interesting visual phenomena, but to develop a skill for producing a controlled expression of the artist's intention is another matter . . .

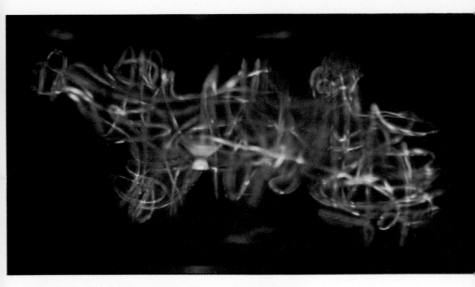

Fig 151 Frank J. Malina 'Paths in Space' Lumidyne Kinetic painting No. 942/1962, 40″x80″

The Lumidyne System

1 Basic principles

The basic components of the Lumidyne system are shown in the diagram. There is a back board for supporting fluorescent or incandescent lights, an electric motor for driving the Rotor, and reflecting surfaces, such as mirrors. Ventilating holes in the back board and at the top and bottom of the case are provided to reduce the temperature within the case. The Stator and Diffusor plates are shown in front of the Rotor. A wire or plastic mesh may be placed in front of the Diffusor to give texture to the picture, and may also be used as a surface for a static painting which is visible when the kinetic painting is not in operation.

The Rotor and Stator are made of glass or transparent plastic material; the Diffusor of ground glass or translucid plastic material. Plate thickness of 2mm is used. Color contrast can be increased by adding a plate of 'black' glass or 'neutral' plastic material in front of the translucid Diffusor plate. . . . The motion of points and areas of light on the Diffusor is determined: (a) by the motion of the Rotor, (b) by the arrangement of opaque and transparent areas on the Rotor and Stator and (c) by the distance between the Stator and the Diffusor. For example, consider the case in which the whole of the Stator is painted with opaque paint except for a fine vertical line intersecting the center of the Rotor, and the whole of the Rotor is painted opaque except for a fine curved line bent in a direction opposite to that of rotation from the centre to the edge of the Rotor. Then, when the Rotor makes one turn, on the Diffusor a point of light will be visible

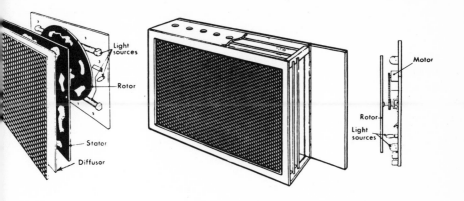

Fig 152 Diagram of the Lumidyne system

which moves vertically upwards from the center of the Diffusor until it disappears at the top edge to reappear again at the center and move downwards until it disappears at the bottom edge. In this way rotational motion can be converted into translational motion.

If radial opaque bands are painted both on the Rotor and Stator then a rotational movement will result on the Diffusor in a direction opposite to that of the Rotor. This effect is especially pronounced when a line source of light from fluorescent tubes is used.

The distance between Stator and Diffusor determines the amount of displacement of the light areas on the Diffusor. The more this distance is increased, the less defined will be the radial opaque lines of the Stator on the Diffusor. I have generally separated the Diffusor from the Stator by a distance of about 2cm.

. . . When a structure of fine transparent lines is made on the Rotor and on the Stator, with light originating from clear incandescent bulbs, a pin-hole camera effect is obtained that causes the filaments in the bulbs to appear on the Diffusor in the form of moving bright calligraphic-type characters.

Color changes are brought about on the Diffusor by painting transparent color areas on either the Rotor alone or on both the Rotor and Stator. Color combinations result, for example, when a yellow area on the Rotor passes a blue area on the Stator to give a green area on the Diffusor . . .

2 Method of painting

I have used the following method in painting a Lumidyne. Usually I have a general idea of the composition and the types of motion to be incorporated. A Lumidyne requiring several Rotors and a number of light sources necessarily demands, before its construction, an idea of its ultimate form in order to decide the location of the lights, Rotors and motors on the back board.

It is after the lights and Rotors have been installed that the moment comes to paint designs on the Rotors for producing the desired motion, and the basic composition of the Stator. At this stage I use black gouache, mixed with an indelible gouache to facilitate adherence to the plastic surfaces, and I continue to make changes in the design and composition until I am satisfied with the result viewed on the Diffusing Screen. In this sketch stage I use colored cellophane attached with cellophane tape to the Rotor and to the Stator to obtain color effects and changes ... The next step is to mark with a grease pencil the designs and colors in the Rotor and the Stator on the unpainted sides of these parts. The cellophane is removed and the gouache paint washed off. The final step consists of painting the opaque portion of the designs with black-board paint and the colored areas in transparent oil paint. Changes can also be made in this final stage until the painting is completed ...

3 Variations of the basic Lumidyne system

For large kinetic paintings a number of Rotors of different diameters and rotated at different speeds may be used ... Rotors may be mounted so as to overlap, and two Rotors may be mounted on the same axis to rotate in opposite directions. The problems of controlling the motion and color changes on the Diffusor in these cases becomes very difficult. I have also given consideration to the possibility of replacing the Rotor by a transparent continuous belt, and by a surface given a complex motion by various kinematic mechanisms.

Special effects can be caused on the Diffusor with the basic Lumidyne system by placing opaque or transparent materials between the Stator and the Diffusor ...

Three-component Lumidyne paintings may also be made without the use of a Diffusor by painting a traditional opaque picture on the Stator with transparent lines and areas. In this case the variety of motions that can be introduced is more limited, and the visual quality of the picture is sharper and 'colder' ...

It is my impression that all color combinations adjacent to each other produced by the direct transmission of light on to a translucid surface ... are pleasing to the eye. In other words, certain color combinations do not appear to clash as they do when opaque pigments are used in painting ...

Articles on kinetic art using a vocabulary developed for traditional painting do not appear, to me, to be adequate. The problem of verbal description is further complicated by the fact that reproductions in two-dimensional form by photographs or drawings cannot transmit the experience produced by kinetic artifacts.

References

1 T. Wilfred, 'Composing in the Light of Lumia',
 J. Aesth. Art Criticism 7,70 (1948)
2 F. J. Malina, 'Improvements in or relating to Light-Pattern Generators',
 Brit. Patent Spec. No. 957, 122 (1962)
3 F. J. Malina, 'Kinetic Painting', *New Scientist* 25, 512 (1965)

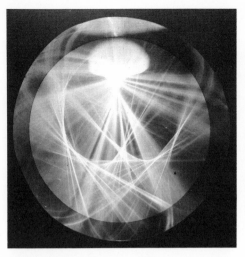
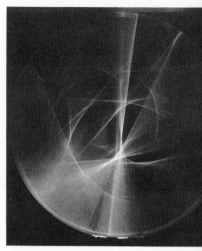
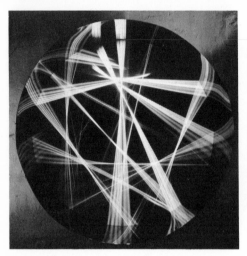
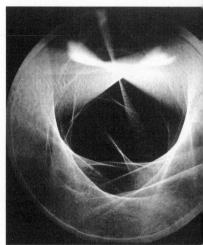

Figs 153, 154, 155, 156 Julio Le Parc:
'Continuel Lumière cylindre',
1962-66, 82 x 62 x 17 cm. Light in
motion. Multiple (selected phases).
Edition of 100
*By courtesy of Galerie Denise René,
Paris*

Materials

I have compiled a selection of items which, apart from the usual artists' materials, might be of interest to the reader. Wherever possible, I have given manufacturers' addresses, but all these materials, or similar ones, are available from equivalent sources in both the UK and the US.

LINE

* Wire: copper, brass, modelling, soldering, florists', etc. Silver & gold (from jewellers' supply shops). Lampshade frames & rings
* Metal: chains, rods, pipes, aluminium tubing, etc
* Wood: cocktail sticks, mouldings, dowels, etc ; balsa stripwood (from model makers' suppliers)
* Bamboo, cane, rushes, reeds: Whines & Edgeler, The Bamboo People, Godmanstone, Dorchester, Dorset, England. Also from: Dryad
.. Handicrafts, Northgates, Leicester (send for catalogue)
* Hemp, twine, nylon, terylene cord, etc
* Plastic tubing
* Venetian-blind slats
* Boning (from dressmaking suppliers)
* Corrugated cardboard
* Printers' type (can be bought secondhand from small commercial printers)
* Plastic, cork, or metal letters & numbers
* *Formatt* (Acetate graphic art aids): Graphic Products Corp., Rolling Meadows, Illinois 60008, USA (Send for catalogue. Also have distributors in UK)
* *Letratone* or *Zip-A-Tone:* dry-transfer sheets, linear patterns (from all artists' materials shops and most stationers')
* Self-adhesive tapes of every description: Chart-Pak Ltd, Station Road, Didcot, Berks, England. Or from W. H. Brady Co. Ltd, 727 W. Glendale Ave, Milwaukee, Wisconsin 53209 USA (Send for complete catalogues from both these firms)

SHAPE

* *Super-Cutawl* Machine (B 15): an advanced piece of equipment for studio/workshop/school. For cut-outs in hardboard, plywood, cloth, thin metal, etc Super-Tools (1951) Ltd, 10 Wendell Road, Shepherds Bush, London W12
* *Superscope:* made by the above firm. A type of opaque projector for making blow-ups from drawings, etc
* Battery operated tool for cutting shapes from expanded polystyrene (*Styrofoam*) sheet: Marley Tile Co. Ltd, London Road, Riverhead, Sevenoaks, Kent
* Floor and wall tiles in cork, polystyrene, self-adhesive Vinyl, etc
* Hardwood guide: 48 examples; illustrated folder available to designers etc from: Timber Trade Federation, Clareville House, Whitcomb St, London WC2
* Papers of every description: Spicers Ltd, 19 New Bridge St, London EC4. Andrews/Nelson/Whitehead, 7 Laight St, NY 10013, NY USA

* Double sided self-adhesive pads, various shapes & thicknesses; Samples from: Kwikstick Products, 37 Leyton Road, Harpenden, Herts, England
* Polished plastic ⎫ Various gauges & colours. In rolls.
* Opaque flexible PVC ⎬ From: Fibrous & Plastic Products Ltd
* Rigid tinted translucent PVC ⎭ Grafton Works, Middlewood St, Salford 5, Lancs, England
* *Cobex* (rigid Vinyl): in sheets; various gauges, colours & surfaces
* Laminates (for engraving) Black/White/Black; or Wh/Bl/Wh; or Bl/Wh/Bl/Wh
* *Polyart* plastic printing sheet. Feels and folds like art paper; non-absorbent, resistant to grease, etc
 The three above products from: BXL Bakelite Xylonite Ltd, Industrial Plastics Division, Manningtree, Essex, England

VOLUME
* Foam rubber or Latex in sheets or blocks (sold for cushions, etc)
* *Polyon* foam cubes, spheres, etc: Rowland Griffiths Ltd, 8 Newman St, London W1 (and other display equipment suppliers)
* Plastic mouldings (round, square, rectangular)
* *Vinagel:* PVC based modelling compound which can be fired in a domestic oven. Alec Tiranti Ltd, 72 Charlotte St , London W1
* *Mod-Roc:* plaster of Paris in rolls, bandages, pieces. Soaked in tepid water it can be moulded; sets after 4 minutes, rock hard in 8 hrs. From: Smith & Nephew Ltd, Bessemer Road, Welwyn Garden City, Herts, England (and artists' materials shops)
* Battery-operated motors, small turn-tables, etc: Auto-Projection Engineers Ltd, 1 Ashdon Road, Harlesden, London, NW10

LIGHT
* Transparent glass painting colours: e.g. *Vitrina;* Winsor Newton Ltd, 51-52 Rathbone Place, London W1; Winsor Newton Inc., 555 Winsor Drive, Secaucas, New Jersey 07094, USA.
* Film design colours; for application on cellulose film or similar surfaces: Winsor Newton
* Photographic Opaque; for spotting pinholes, blocking out, on negatives & slides
* Fluorescent colours: e.g. *Day-Glo; Fluorart; Aquaflare* (the last two from Winsor Newton)
* Aerosol spray paints; metallic & fluorescent
* Glass frosting: aerosol ground glass spray to reduce glare. From E. W. Jones (2 Stik) Ltd, Fountain House, 1063 Stockport Road, Manchester 19, England
* Glass beads & drops: from jewellers' supply shops, Woolworths', etc
* Glass blocks (white & coloured): *Insulight;* Pilkington Bros Ltd, Selwyn House, Cleveland Row, London SW1
* *Perspex, Oroglass, Plexiglass. Perspex* is made by Imperial Chemical Industries, Plastics Division, Welwyn Garden City, Herts, England
* I.C.I. also make *Melinex* clear plastic sheeting (*Mylar,* by Dupont, in the US), and *Crinothene* translucent plastic sheet with crêpe-like surface, used for lampshades, etc
* Self-adhesive PVC film in transparent colours: e.g. *Transpaseal*
* Tracing cloth, *Kodatrace,* etc: from drafting & artists' materials shops
* Buckram (stiff translucent cloth, uneven weave)

* Interlining (pleasantly textured, translucent): from dress fabrics shops
* Metallised sheet materials: e.g. Flectafoils Ltd, 72 Rochester Row, London SW1
* *Mirror-Flex* (mirror in flexible sheets with sectional cuts): Opals (Mirror-Flex) Ltd, Clacton-on-Sea, Essex, England
* *Mirrorlite* (lightweight mirror): Pearson Lightweight Mirror Co, 92 West Bar, Sheffield S 3-8 PN, England
* Anodised aluminium wall tiles
* *Transpalite* (Methyl Methacrylate): Stanley Plastics Ltd, Hambrook, Chichester, Sussex, England (specialise in embedding objects in acrylic blocks; also manufacture seamless acrylic tubes, cylinders, rods, discs, etc) ˙
* *Formafilm* (quick-drying transparent plastic base, easily moulded on to wire forms, etc): Joli Plastics Co, Box 3006, Torrance, California, USA
* Special effects projectors (*Kaleidospot* etc): Strand Electric & Engineering Co Ltd, 29 King St, Covent Gdn, London WC2. Also in the US: Strand Electric Inc., 3201 North Highway 100, Minneapolis, Minnesota 55422

Useful periodicals for sources of new materials
Display Equipment News International (quarterly) Newman Books Ltd, 68 Welbeck St, London W1

Display, (monthly) Mallard Publishing Co. Ltd (subsidiary of Blandford Press Ltd), 167 High Holborn, London WC1

Adhesives Directory (1967-68) A. S. O'Connor & Co. Ltd, 30 Paradise Road, Richmond, Surrey, England

Bibliography

Roget's Thesaurus
Penguin Books, Harmondsworth 1966

The Artist's Handbook of Materials and Techniques
Ralph Mayer, Viking Press, New York 1957

Plastics as an Art Form
Thelma R. Newman, Pitman, London 1965; Chilton, Philadelphia and New York 1964

Basic Design: the dynamics of visual form
Maurice de Sausmarez, Studio Vista, London; Reinhold, New York 1964

Printmaking: a medium for basic design
Peter Weaver, Studio Vista, London; Reinhold, New York 1968

The Art of Color
Johannes Itten, Reinhold, New York 1962

Colour: basic principles and new directions
Patricia Sloane, Studio Vista, London; Reinhold, New York 1968

Language of Vision
G. Kepes, Paul Theobald, Chicago 1951

Optical Illusions and the Visual Arts
Ronald G. Carraher and Jacqueline B. Thurston, Studio Vista, London 1966; Reinhold, New York 1966

Graphic Perception of Space
Frank Mulvey, Studio Vista, London; Reinhold, New York 1969

Mathematical Models
H. M. Cundy and A. P. Rollett, Oxford University Press, London 1961

Optical and Kinetic Art
Michael Compton, Tate Gallery ('Little Book' Series) London 1967

Kinetic Art
Guy Brett, Studio Vista, London; Reinhold, New York 1968

The Origin of the Motion Picture
D. B. Thomas, Science Museum Booklet, Her Majesty's Stationery Office, London 1964

Light and Colour (from a useful children's series: 'How & Why')
Harold J. Highland, Transworld, London 1967; Wonder Books, New York

The Written Word (Symbol Series)
Etiemble, Prentice Hall International, London 1962; Robert Delpire, Paris

The Chinese Theory of Art
Lin Yutang, Heinemann, London 1967

The History of Magic
Kurt Seligmann, Pantheon Books, New York 1948

Prehistoric and Primitive Man
Andreas Lommel, Paul Hamlyn, London 1966

The Book of Signs
Rudolf Koch, Dover Publications, New York 1930

Cybernetic Serendipity: the computer and the arts
Studio International, London 1968 (special issue)

Heaven and Hell in Western Art
Robert Hughes, Weidenfeld and Nicolson, London 1969